Pics or It Didn't Happen

Images Banned from Instagram

Edited by Arvida Byström & Molly Soda
Foreword by Chris Kraus

PRESTEL
MUNICH · LONDON · NEW YORK

Contents

@pics_or_it_didnt_happen

We removed your post because it doesn't follow our Community Guidelines.

Please read our Community Guidelines to learn what kinds of posts are allowed and how you can help keep Instagram safe.

OK

Instagram's Community Guidelines

The Short

We want Instagram to continue to be an authentic and safe place for inspiration and expression. Help us foster this community. Post only your own photos and videos and always follow the law. Respect everyone on Instagram, don't spam people or post nudity.

The Long

Instagram is a reflection of our diverse community of cultures, ages, and beliefs. We've spent a lot of time thinking about the different points of view that create a safe and open environment for everyone.

We created the Community Guidelines so you can help us foster and protect this amazing community. By using Instagram, you agree to these guidelines and our Terms of Use. We're committed to these guidelines and we hope you are too.

Overstepping these boundaries may result in deleted content, disabled accounts, or other restrictions.

• Share only photos and videos that you've taken or have the right to share.
As always, you own the content you post on Instagram. Remember to post authentic content, and don't post anything you've copied or collected from the Internet that you don't have the right to post. Learn more about intellectual property rights.

• Post photos and videos that are appropriate for a diverse audience.
We know that there are times when people might want to share nude images that are artistic or creative in nature, but for a variety of reasons, we don't allow nudity on Instagram. This includes photos, videos, and

some digitally-created content that show sexual intercourse, genitals, and close-ups of fully-nude buttocks. It also includes some photos of female nipples, but photos of post-mastectomy scarring and women actively breastfeeding are allowed. Nudity in photos of paintings and sculptures is OK, too.

People like to share photos or videos of their children. For safety reasons, there are times when we may remove images that show nude or partially-nude children. Even when this content is shared with good intentions, it could be used by others in unanticipated ways. You can learn more on our Tips for Parents page.

• Foster meaningful and genuine interactions.
Help us stay spam-free by not artificially collecting likes, followers, or shares, posting repetitive comments or content, or repeatedly contacting people for commercial purposes without their consent.

• Follow the law.
Instagram is not a place to support or praise terrorism, organized crime, or hate groups. Offering sexual services, buying or selling firearms and illegal or prescription drugs (even if it's legal in your region) is also not allowed. Remember to always follow the law when offering to sell or buy other regulated goods. Accounts promoting online gambling, online real money games of skill or online lotteries must get our prior written permission before using any of our products.

We have zero tolerance when it comes to sharing sexual content involving minors or threatening to post intimate images of others.

• Respect other members of the Instagram community.
We want to foster a positive, diverse community. We remove content that contains credible threats or hate speech, content that targets private individuals to degrade or shame them, personal information meant to blackmail or harass someone, and repeated unwanted messages. We do generally allow stronger conversation around people who are featured in the news or have a large public audience due to their profession or chosen activities.

It's never OK to encourage violence or attack anyone based on their race, ethnicity, national origin, sex, gender, gender identity, sexual orientation, religious affiliation, disabilities, or diseases. When hate speech is being shared to challenge it or to raise awareness, we may allow it. In those instances, we ask that you express your intent clearly.

Serious threats of harm to public and personal safety aren't allowed. This includes

specific threats of physical harm as well as threats of theft, vandalism, and other financial harm. We carefully review reports of threats and consider many things when determining whether a threat is credible.

• Maintain our supportive environment by not glorifying self-injury.

The Instagram community cares for each other, and is often a place where people facing difficult issues such as eating disorders, cutting, or other kinds of self-injury come together to create awareness or find support. We try to do our part by providing education in the app and adding information in the Help Center so people can get the help they need.

Encouraging or urging people to embrace self-injury is counter to this environment of support, and we'll remove it or disable accounts if it's reported to us. We may also remove content identifying victims or survivors of self-injury if the content targets them for attack or humor.

• Be thoughtful when posting newsworthy events.

We understand that many people use Instagram to share important and newsworthy events. Some of these issues can involve graphic images. Because so many different people and age groups use Instagram, we may remove videos of intense, graphic violence to make sure Instagram stays appropriate for everyone.

We understand that people often share this kind of content to condemn, raise awareness or educate. If you do share content for these reasons, we encourage you to caption your photo with a warning about graphic violence. Sharing graphic images for sadistic pleasure or to glorify violence is never allowed.

Help us keep the community strong:

• Each of us is an important part of the Instagram community. If you see something that you think may violate our guidelines, please help us by using our built-in reporting option. We have a global team that reviews these reports and works as quickly as possible to remove content that doesn't meet our guidelines. Even if you or someone you know doesn't have an Instagram account, you can still file a report. When you complete the report, try to provide as much information as possible, such as links, usernames, and descriptions of the content, so we can find and review it quickly. We may remove entire posts if either the imagery or associated captions violate our guidelines.

• You may find content you don't like, but doesn't violate the Community Guidelines. If that happens, you can unfollow or block the

person who posted it. If there's something you don't like in a comment on one of your posts, you can delete that comment.

• Many disputes and misunderstandings can be resolved directly between members of the community. If one of your photos or videos was posted by someone else, you could try commenting on the post and asking the person to take it down. If that doesn't work, you can file a copyright report. If you believe someone is violating your trademark, you can file a trademark report. Don't target the person who posted it by posting screenshots and drawing attention to the situation because that may be classified as harassment.

• We may work with law enforcement, including when we believe that there's risk of physical harm or threat to public safety.

For more information, check out our Help Center and Terms of Use.

Thank you for helping us create one of the best communities in the world,

The Instagram Team

Foreword

Chris Kraus

In Rachel Nagelberg's provocative novel *The Fifth Wall*, the lapsed artist Sheila B. Ackerman considers the work of a video artist formerly employed as a "virtual topologist" for Microsoft's Bing Maps platform:

> *We are recording the whole world*, he had said to me. ... *This is what art's become*, he said. *A virtual simulacrum, an information rig.* I had wanted to reply that the notion of art was changing—that to be a contemporary artist was not necessarily to identify yourself with the medium, as a painter, or sculptor, creating something unseen—as a recluse from society—but now as a revealer of what was already there, in new combinations of forms and images, a person both inside and outside of space and time.

This idea—that the job of contemporary art is more to devise new means of pattern recognition than to "create" any new thing—describes Arvida Byström and Molly Soda's bold and provocative work perfectly.

Byström and Soda are both artists, and this book is an act of random curation at least twice removed. As the artists explain, *Pics or It Didn't Happen* began as a kind of graveyard, a "ceremony for the lost photos" deleted by censors from their Instagram posts. "can we make a ceremony for all the banned ig posts," Byström tweeted, and then Soda proposed making this book. Soon, the artists opened a call to their 207,600 Instagram followers, inviting them to send images that had been deleted or banned from their own accounts. As the authors point out, while collecting images for the book, "We quickly began to see patterns in

the types of images that had been subjected to censorship. These include photographs of genitalia, bare butts, female nipples, period stains, liquids resembling semen or vaginal secretions, pubic hair." Still, in statistical terms, *Pics* was composed through a highly stratified sampling method: the followers of both artists' accounts tend to be, as Byström remarks, "a lot of white abled cis young women, often pretty thin … these kinds of people tend to feel more entitled to their bodies and feel more comfortable showing them." Or, to extend this assertion: the numbing, traumatic images of gigantic dildos, beheadings, and human roadkill that are routinely removed by the outsourced "content moderation" workers in Bombay or Manila will not appear in this book. The images that Byström's and Soda's followers most often share are photographs of their own, or perhaps other, female bodies: naked, splattered with paint, partially clothed, awkwardly sexualized and even— most inexplicably censored—fully clothed in repose.

Removed from the screen, the pictures attain a strange gravitas that is subtly troubling. I'm reminded of S-21 photographs of soon-to-be-executed Khmer Rouge refugees that invite museumgoers to wallow in a suspended state of dramatic irony, in which we know the fate of these subjects, while they do not. Awash in white space on the page, the pictures in *Pics* seem to be striving toward an unattainable revelation of self, as if the bikini-brief-clad vagina bifurcated by seamed fishnet tights, the isolate nipple, or the faint menstrual blood on a pair of sweatpants might hold the keys to intimacy. And who's to say they do not? They are attempts to break through the screen by using the screen.

The idea that these self-portraits of bodies are merely "exhibitionistic" or "narcissistic" is absurd. As Nagelberg writes, the satellites that orbit the sky are nothing but "billion-dollar 'selfie' apparatuses … Is this the endpoint to our exploration? … A dead world made to look alive."

Chris Kraus is the author of four novels, including Summer of Hate *and* I Love Dick, *and two books of cultural criticism. Her critical biography of Kathy Acker will be published by Semiotext(e) in 2017.*

Arvida Bystrom
25 September 2015 · Twitter · 🔒 ▾

can we make a ceremony for all the banned ig posts

👍 Like 💬 Comment ➦ Share

👍 Alessandra Celauro, Tenika Thompson and 66 others

Molly Soda we should make a book ✕
Like · Reply · 👍 4 · 25 September 2015 at 10:39

Introduction

Arvida Byström & Molly Soda

We originally set out to make a book of photos that have been removed from Instagram because we and many of our peers are constantly—and very vocally—frustrated by the censoring of our images. What started as a comment on a Facebook thread spiraled into something much larger and, as time progressed, more complicated.

Instagram, one of the most popular social media platforms, is an application where users can upload and showcase photos—commonly, images from their everyday lives. Most smartphone owners actively use the app, whether it is for a private personal account, or belongs to a celebrity, or even a corporation. Like most online communities, Instagram has a pretty lengthy set of guidelines (or rules) that users must abide by. Its Terms of Use state that people "may not post violent, nude, partially nude, discriminatory, unlawful, infringing, hateful, pornographic or sexually suggestive photos or other content via the Service." The nature of this wording often leads one to wonder what exactly violates these terms and what might be able to slip past. When criticized for their strict censorship rules, Instagram tends to pass the blame onto the Apple App Store, which has strict anti-pornography guidelines.

Our choice to archive these "removed" images in a book parallels the elevation that happens when something is censored. When an image is taken down from Instagram, we receive a notification about it but are not told which photo was removed or exactly why. We have to scroll through our feeds, sometimes deep into our archives to find the culprit. This makes the image in question more important in our minds, perhaps because we spend more time thinking about it—it burns a hole into our feeds. Because digital media is seen as fleeting, taking the time to compile, edit,

and physically print these "lost" images gives them more attention, letting them take up space and carry weight.

In order to collect content for the book we reached out to artists who had struggled with having content taken down, as well as put out an open call for submissions on Instagram itself. We quickly began to see patterns in the types of images that had been subjected to censorship. These include photographs of genitalia, bare butts, female nipples, period stains, liquids resembling semen or vaginal secretions, and pubic hair. Generally, the photos submitted were mostly of bodies, as opposed to violent imagery— this bias was probably due to the content of our own Instagram feeds and the followers we attract rather than indicative of the overall nature of banned content.

The book evolved into a conversation about bodies—specifically, which bodies are seen as "dangerous" and which ones as "safe." Take, for example, two images of people wearing the same bathing suit; one has shaved or waxed their bikini area while the other has not. The image of the hair-free body is less likely to be taken down. The removal, or erasing, of certain images speaks volumes about what is seen as acceptable and normal in contemporary culture. A common theme among the photographs submitted to us is the types of bodies pictured: primarily white-passing, thin,

cisgender. This leads us to wonder: who feels more entitled to post these kinds of images?

Through this process we also discovered the traumatic and emotionally taxing labor that goes into censoring, as discussed in Sarah T. Roberts's essay (see pages 17–21). This involves outsourcing low-paid workers to look at and evaluate explicit, graphic, and often violent imagery in order to keep the app "safe," bringing into question whose safety is being protected, and why.

Pics or It Didn't Happen is not a book against censorship. Nor is it a book curated by people who want to do whatever they please, or believe a society without morals would be a better place. This book is not a how-to guide on feminism. Posting a nude selfie, or not posting any selfies at all, does not determine whether you are a feminist. To put it simply, this book consists of photos taken by people with a range of conflicting views but one thing in common: they have all had their photos taken down from Instagram due to the platform's Community Guidelines.

Aggregating the Unseen

Sarah T. Roberts

• We reserve the right to refuse access to the Service to anyone for any reason at any time.

• We reserve the right to force forfeiture of any username for any reason.[1]

By any measure, Instagram is a global social media phenomenon. Over 95 million photos and videos are uploaded to or shared via it each day, and it has a total of 500 million users worldwide (with over 80 per cent of users coming from outside the United States)—all achieved in less than six years of existence.[2] Signaling its belief in Instagram's potential for growth, in 2012 Facebook purchased Instagram for a combined cash and stock deal valued, at the time, at over $1 billion. This was an impressive amount, considering that Instagram had yet to formulate a means of generating revenue at the time of its acquisition. It has since developed a variety of mechanisms for doing so, including the location- and interest-based advertising that appears in users' photo streams, based on the robust advertising capacity of Facebook and backed by that firm's access to capital.

Instagram relies on its users possessing mobile smartphones (its desktop access is limited in functionality).[3] Users log aspects of their everyday life on Instagram, from "found" moments to the totally constructed. Celebrities (Beyoncé, Lena Dunham, assorted Kardashians, for example) populate the platform with "intimate" shots of their personal lives, while the platform itself has spawned celebrities of its own or propelled their individual brands to greater heights. Others have explored the limits of the platform as a space for art or self-expression, or as a means to connect with like-minded people through a shared aesthetic or common interests.

Users' content frequently blurs the line between spontaneous and staged, and the focus is often less on any particular

sense of authenticity than it is on providing aspirational fodder for followers. In any case, it relies on the willingness of its user base to continually, relentlessly upload new photos and videos that, in turn, keep other users coming back to refresh and scroll through their photo stream.

• We may, but have no obligation to, remove, edit, block, and/or monitor Content or accounts containing Content that we determine in our sole discretion violates these Terms of Use.[4]

As with virtually all mainstream social media platforms and applications, user-generated content on Instagram is governed and disciplined via a set of platform-defined rules, which it refers to somewhat colloquially as its "Community Guidelines." These rules govern user engagement on Instagram, which reserves the right to enforce them as it sees fit and according to its own opaque interpretation. A perusal of Instagram's Community Guidelines web page (see pages 8–11) reveals what the platform attracts, and struggles to control: pictures and videos of self-harm or self-injury, images glorifying eating disorders, images of exploitation, underage children using the platform, among other subjects.

In order to manage rule violations and subsequent takedowns, Instagram and

platforms like it rely on a worldwide legion of what I call commercial content moderation (CCM) workers, who screen images, typically after they have been reported by other users as being in violation of the Community Guidelines. Content moderators must be arbiters of good taste and social norms, applying their own sensibilities to and through those of the platform, making decisions about what material to remove and what to leave up. It is a task that demands precision of the human mind— at present, no computer can replicate the human capacity for CCM—yet workers are often given only a few seconds to complete each task, making the job high-paced and frequently stressful, and extremely rote at the same time. My own academic research has focused on these CCM workers, whose repeated exposure to user uploads deemed too awful to be left standing on mainstream platforms like Instagram frequently takes a toll on them in both their work and private lives. From the platform's perspective, CCM labor is essential, yet it tends to be outsourced and subcontracted, and remunerated poorly.

The hidden processes by which the labor of CCM is undertaken contribute to the notion of social media, and all its attendant parts, as immaterial and ethereal, rather than grounded in the physical world and reliant upon human actors. CCM's invisibility

enhances the myth that what ends up on a site is there by purposeful design of artificial intelligence and algorithmic computation, rather than by human decision-making and, often, dumb luck. Social media firms take advantage of the ability to offshore this labor en masse to sites in the global South, thus distancing themselves, metaphorically and geographically, from the everyday working conditions of CCM workers, as well as blanketing those workers in non-disclosure agreements that preclude them from speaking about their work and experiences. It introduces plausible deniability for social media companies, who can focus on the fun and more glamorous aspects of product innovation at their Silicon Valley headquarters, while making the task of clean-up, and the risks of exposure to inappropriate content, a problem mostly for people on the other side of the world.

• You may not post violent, nude, partially nude, discriminatory, unlawful, infringing, hateful, pornographic or sexually suggestive photos or other content via the Service.[5]

For users who push the envelope of the platform's tolerance of imagery and video depictions that straddle mainstream tastes, norms, politics, and concepts of safety, the experience of having an image deleted is a frustrating one. When a photo is removed,

the Instagram user to whom it belongs has virtually no means, beyond referring to the broadly drafted Guidelines, to understand who complained about it or why—and no mechanism for mounting any significant appeal. Some Instagram users have responded to takedowns by reposting the same deleted image over and over again, drawing the attention of others to their cause and sometimes resulting in their being banned from the platform. In some cases, these acts (or actions) have instigated policy change, such as the relaxing of Instagram's outright ban on images of breastfeeding or menstrual blood. Increasingly, the frustration is with the fact that such policies are not equally enforced or relaxed—a problem that becomes more understandable once one realizes that human beings are largely responsible for the adjudication process.

• Post photos and videos that are appropriate for a diverse audience: We know that there are times when people might want to share nude images that are artistic or creative in nature, but for a variety of reasons, we don't allow nudity on Instagram. This includes photos, videos, and some digitally-created content that show sexual intercourse, genitals, and close-ups of fully-nude buttocks. It also includes some photos of female nipples, but photos of post-mastectomy scarring and women actively

breastfeeding are allowed. Nudity in photos of paintings and sculptures is OK, too.[6]

When subjects of images include the female body (in a variety of stages of dress and nudity), people of size, people of color, people who are gender variant, or those who otherwise find themselves occupying the margins of social space, takedowns seem to be part of the negotiated cost of using Instagram for such (self-)expression. When marginalized identity markers serve as deletion fodder, the effects of takedowns are rendered even more personal. It is a trade-off that underscores the very nature of Instagram itself, which is not a gallery, or a living room, or a shared private space among friends—despite masquerading as such.

Instagram (and other social media platforms like it, such as its parent company, Facebook) exist in a nuanced and liminal space, deliberately straddling and even blurring lines between public and private, leisure and labor, fun and frustrating—even frightening. For-profit companies, they fill a void created through the shrinking or outright absence of public space and the loss of institutions in the public sphere, and proliferate even as institutions that have also occupied similar liminal positions but with more overt responsibility to the public, such as newspapers and print media, struggle for survival. The immediacy and sheer capacity to connect is alluring and overrides concerns, for many users, about privacy and the potential loss of control over their self-expression (relegated simply to "Content" in the Community Guidelines).

The deleted images aggregated here gesture at the politics of Instagram and, by abstraction, at those of a multitude of mainstream social media platforms. The labor of the images' production and the emotional and technical management of the constant omnipresent threat or actual act of takedown is also implicit in this collection. Media scholar Magdalena Olszanowski cleverly refers to such management labor as "sensorship"—noting also that it is now being turned against itself, as a form of feminist subversion, by some users.[7] Likewise, CCM workers and their labor are represented implicitly in this collection, their acknowledgment a perhaps unintended but altogether powerful byproduct of the grouping together of these images.

The experience of engagement with Instagram is isolating and individual where takedown is concerned, despite the platform's self-styling as a site of community and collectivity. To be sure, the invisible interventions of content moderators are hardly showcased, and seldom acknowledged, by the platforms who rely

upon them, making what artists Arvida Byström and Molly Soda offer in this volume all the more compelling. It is an aggregation of the unseen, and a uniting of individually deleted images into a collection, yielding an attempt, at least, at a sense-making project among the photos and videos that have been brought together with their shared characteristic of absence. As someone concerned with the process of deletion and removal of user-generated content on social media platforms, to see the material results of that process represented in this way is fascinating.

Of course, the photos here do not necessarily represent the totality of imagery that is subject to Instagram deletion. Instead, the editors offer a curated, compelling and even confrontational glimpse at what one subset of users—their motives largely unknown and unknowable—has attempted to disseminate. Some images will likely shock or even repulse the readers of this book. Others will provoke befuddlement as to what could have been the cause of their removal, such as why a nipple is considered sexual, or why sexuality is intrinsically bad, dangerous, or to be hidden, or why a black woman wearing a hijab is inherently problematic on Instagram. In each case, it is because these representations are those also deemed dangerous and threatening in everyday life—as part of the wider

popular demonization of entire classes of racial, sexual, and gender identities. What this collection of redacted images does, ultimately and fundamentally, is to link these private absences and unremarked-upon removals to much larger political questions about representation of (among other things) race, gender, sexuality, and the politics of acceptability in society in our contemporary moment. To render visible these deleted personal, expressive moments is to question the norms by which such images are removed in the first place, and to reflect upon the power and politics behind such decision-making.

Sarah T. Roberts is Assistant Professor of Information Studies at UCLA. Find her on the web at illusionofvolition.com.

[1] Instagram, "Terms of Use," General Conditions 4 and 5, https://help.instagram.com/478745558852511, January 19, 2013.
[2] Instagram, "Press: Stats," www.instagram.com/press, accessed September 7, 2016.
[3] According to Pew Research Center, in 2015, "Nearly two-thirds of Americans are now smartphone owners, and for many these devices are a key entry point to the online world." Aaron Smith, "U.S. Smartphone Use in 2015," Pew Research Center, www.pewinternet.org, April 1, 2015.
[4] Instagram, "Terms of Use," General Conditions 6, https://help.instagram.com/478745558852511, January 19, 2013.
[5] Instagram, "Terms of Use," Basic Terms 2, https://help.instagram.com/478745558852511, January 19, 2013.
[6] Instagram, "Community Guidelines," https://help.instagram.com/477434105621119, accessed September 14, 2016.
[7] Magdalena Olszanowski, "Feminist Self-imaging and Instagram: Tactics of Circumventing Sensorship," *Visual Communication Quarterly* 21/2 (2014): 83–95. DOI: 10.1080/15551393.2014.928154.

Virgo Woman Switches between the Same Apps for Hours Imagining Herself in Situations That Will Literally Never Exist

Merray Gerges

Sarcoptes scabiei crawl beneath the epidermis of my knuckles, my fingers, my hips, and my nails as I write this. The female mite burrows into the skin, where it lays its eggs and fecal matter; this is visible to the naked eye only in papulae. The erratic red lines of varying widths and lengths that mark the itchiest spots indicate the furthest extent of my addressing the infestation. Though I never permit the length of my nails to protrude past the tips of my fingers, I've let them grow—despite creating a hospitable crevice between the nail plate and the finger—to scratch where my hands can reach. The female mite is said to stay below the neck, clear of my head, but is it really

not going to have an effect when I scratch my scalp or pop my blackheads or pick my nose or peel skin off my chapped lips? What happens when I push my DivaCup in or pull it out, or when I scrape the *keratosis pilaris* (which is genetic, but papular like the scabies) on the backs of my arms and thighs, or when I gnaw at my hangnails so incessantly that they lay bare my flesh? Could my body's internal temperature be as high as that of the dryer required to eradicate the mites in the textiles that have made contact with my skin?

The first time I contracted scabies was from a friend-with-benefits who claimed to understand me like no other white man

could because he'd taken a number of university classes on my mother tongue, then spent several months after graduating volunteering in a desert. He called to tell me about it soon after our encounter, but it would be anywhere between four and six weeks before symptoms would show—before I could treat it with permethrin, an over-the-counter neurotoxic insecticide, which the pharmacist sold me with a look of pity and reticence (even though contagion requires prolonged contact). The second time, this time, symptoms showed within just days of exposure, from two weeks of sharing a bed with my brother—who's been repeatedly censored on Instagram himself, once for mimicking Kim Kardashian's 2007 *Playboy* photo shoot in which she uses strings of pearls to strategically conceal what emoji would obscure—who couldn't trace where he'd got it. The first of the two weeks we shared a bed was in middle-of-nowhere New Brunswick on our annual end-of-summer trip, planned by my parents to stage interventions into whatever crisis they perceive one of their three offspring to be suffering that year. Last year it was the virality of said Instagram account outing my brother to them in a Chipotle in suburban Portland, Maine. This year, in between hour-long drives to tide-sensitive bays, and national parks we didn't pack the shoes to navigate, the intervention's subject was my twenty-

year-old sister's eating disorder, which she would go on to vehemently deny.

I returned from this trip to a heat wave and a six-legged maroon insect brazenly sauntering across the surface of my unruffled duvet. I led it to climb onto my new library card after I took a pic of it, and the instant I applied pressure to it with another card, its body ruptured and the blood within it—somebody else's—surged.

Seeing a bed bug in broad daylight indicates its dire thirst, and after you pile your belongings into garbage bags, the exterminator—whose casualness either assures you they've seen it all before or makes you suspect they might be scamming you—asks you to leave your home for a number of hours and that you definitely sleep in your bed that night: the pesticide will fail in the absence of bait.

People who have suffered from and survived either infestation will describe a paranoia-induced phantom itch for months to follow. Apprehension of physical proximity laces every interaction—and rightfully so—even when they're (tentatively) obliterated. Both types of bug are nocturnal, and their eggs are more potent than what laid them, and because they only leave traces on a human body when it is allergic to them, anyone can be an asymptomatic carrier. You indulge the vigorous, relentless compulsion to excise the surface of your skin

from the revulsion at being trapped in your body, a body that no one would come near if they knew—and they ought to know—what it hosts. Your body is abject.

The abject is not what is unsanitary, but what Julia Kristeva characterizes as that which "disturbs identity, system, order." The abject hovers in a liminal space in between the subject, within, and the object, without. The images expelled by Instagram are of ungroomed pubes; period blood in and on the body and on fabric that has come into contact with it; webs of saliva inside a mouth; pierced nipples or nipples piercing through a CD hole; mostly thin and mostly white-passing and mostly cis bodies. When Instagram jettisons these images, violently and radically casting them out of the cultural world, it renders the innocuous abject. "And yet, from its place of banishment, the abject does not cease challenging its master," Kristeva says.

Though indignation at censorship is reasonable—the erasure is violent, dispossessing the user of their agency—the nonchalance with which these users are able to post in the first place is a privilege. Not every feminist can be body- or sex-posi. I have yet to fully shed the vestiges of a faith that I disavowed when I was 21. I still don't have the guts to post an image that would ever elicit consideration for deletion. I just bought myself my first vibrator, a LELO,

and hesitate to post a video of its so-called cutting-edge come-hither mechanism. Writing this essay was the closest I could come to portraying my body at its most vulnerable, its most abject, and the closest I could get to participating in a project with a premise like this.

Merray Gerges is a critic based in Toronto (for now). She has written for Canadian Art, C Magazine, *Hyperallergic, and the* Walker Art Center. *Her work ranges from questioning the mechanisms of whiteness in the art world to fleshing out the erotic aesthetics of slime, miniature cooking, and pimple-popping videos. She posts PG selfies on Instagram: @merrayrayray.*

THINX

Alexis Anais Avedisian

In early summer 2015, pastel-hued advertisements were scattered across several central subway stations in Brooklyn and Lower Manhattan. The campaign was for THINX, a new apparel brand producing absorbent underwear "for women with periods," as its tagline professes. In creating a novel microfiber design that claims to instantly soak up any potential leakage, THINX promises days-long dryness and protection, regardless of one's use of ordinary feminine hygiene products such as tampons and panty liners.

To hone in on the product's self-proclaimed innovation the ads stylistically mimicked those created for present-day digital commodities, in that they put a fertile twist on the sterile minimalism often associated with tech industry branding. Models of various ethnicities and body types were photographed in mid-motion, quite similar to how an iPhone—stationary in the majority of Apple Inc.'s ads—still appears energized against the technology company's

signature white background. The yolk and clear albumen of an oozing, cracked egg were used throughout the campaign as a metaphor for ovulation. And, in an ode to Georgia O'Keeffe, a hyper-detailed shot of a grapefruit became a tongue-in-cheek depiction of female anatomy.

Such visual signifiers worked to provide THINX with a more conceptual brand identity, one which distinguished the newcomer from marketplace staples like Tampax and its generic siblings. While Tampax ads are notoriously coy and unrealistic, utilizing a mysterious blue liquid in lieu of blood, THINX ads are authentic, approaching bodily functions with a level of pragmatic chicness, afforded by the brand's association to an of-the-moment, fashion-meets-technology culture. Instead of asking those menstruating to live life on the edge, perpetually searching for a restroom in which to freshen up, THINX is attempting to streamline women's entire monthly cycles, allowing them to unabashedly free

bleed without suffering any potentially embarrassing consequences.

In light of this, it seems obvious that THINX would be adept at online marketing. Sure enough, just as the ads augmented my daily underground commute, they began to flood (no pun intended) mostly all of my social media feeds. On Facebook, sponsored articles pinged back to content aggregators like *Dazed Digital* and *Vice* appeared on my timeline ritually, with each publication heralding the product for its seditious originality. On Instagram, recently uploaded posts by THINX's official account were targeted directly to me; each browse of the app summoned a new image and therefore a new, conclusive reminder to purchase the product.

Campaigning à la THINX has recently refueled conversations surrounding commodity feminism, a subset of the broader feminist discourse that has remained, since the early 1960s, concerned with how, and why, specific feminist persuasions are extracted by brands for their commercial potential. The current interest in this topic is directly related to the ubiquitous use of social media platforms, where much present-day conversation on identity politics is originating, alongside viral marketing tactics. As many of the most popular social networks are still in part funded by the sale of user-specific data to advertisers, it is only

in a social media corporation's best interest to promote ads that are socially engaged and inherently representative of the issues users care about. Ads that imitate user ideologies, like THINX's, are more likely to be shared and therefore more likely to generate revenue for the platform through a continued brand-to-platform relationship.

It would be foolish for marketers to ignore the effectiveness of commodity feminism. Women hold the highest purchasing power in today's economy, and campaigns are more likely to be successful if they are able to genuinely portray their realities. Conceivably, this is the underlying motivation that has called upon advertisers to use "real" women instead of "models"—real women are relatable, while models are capitalist clichés that most young feminists are eager to write off as no more than mannequins, upholding the same impossible body standards that left them traumatized after outings to Abercrombie & Fitch in junior high. In relation to the social media feed space, the marketer's goal, it seems, is to create as little distinction as possible between a female user's post and the ad itself. The THINX brand in particular has this concept down pat: the campaign isn't asking menstruating women to hide the reality of their blood; it is instead giving them a platform, through advantageous consumerism, to socially normalize a reality once conventionally

viewed as undignified. This is not unlike the self-deprecating style of content that has grown popular on Twitter, heralded by hilariously reprehensible prolific users like Melissa Broder (@SoSadToday) and Darcie Wilder (@333333333433333).

Ironically enough, a mere few months before the THINX frenzy, something suspicious happened. Visual artist and Instagram sensation Rupi Kaur had a series of photographs of a fully clothed model, her clothing lightly stained with period blood, twice removed from the platform as a violation of its terms of service (see page 283). Kaur's work is distinctly feminine, using the soft lighting and pastel coloring that has allowed brands like THINX to appear unassumingly authentic. Such nuanced comparisons bring about a crucial question: why is it that feminist-leaning ad campaigns are allowed to grow massively popular on social media platforms, but user-generated content of a similar nature is often censored?

Facebook, the world's largest social network, with over three billion active users, has been fixated on promoting social conventionalities since its inception. This fundamental aspect of Facebook's brand didn't change when the corporation announced plans to purchase stand-alone mobile imaging app Instagram for $1 billion shortly after its stock market launch in April 2012. A progressive yet calculated move, founder and CEO Mark Zuckerberg saw potential for the then-startup to contribute to his enterprise in ways that were still exploratory at the time. Threatened by Instagram's loyal following and iPhone-specific network of 27 million users, Facebook was looking to minimize competition in the growing market for social photography. On the day of the acquisition, Zuckerberg posted the following status update on his personal profile: "For years, we've focused on building the best experience for sharing photos with your friends and family. Now, we'll be able to work even more closely with the Instagram team to also offer the best experiences for sharing beautiful mobile photos with people based on your interests." Of this announcement, "friends" and "family" are the most distinct terms, concretizing the traditional values behind Facebook's ethos.

As such, both Instagram's and Facebook's community guidelines explicitly state that users themselves own the content they share; a social photograph wouldn't be "social" if it wasn't allowed to accurately portray that user's lifestyle. However, simply owning content doesn't mean that it's safe from censorship, or even under the user's authority once they've made the conscious decision to click the "post" button. An image that threatens Facebook's mission to create the ultimate family-friendly scrapbook is

likely to be shunned—this includes any image that contains sex, nudity, or similar impressions deemed as profane. Is it appropriate for sexualized images shared by adults to circulate on a platform that also allows thirteen-year-olds to build meme groups? Probably not—at least according to Facebook's moderators, who, alongside algorithmic systems that scan photographs, are tasked with flagging and removing images posted in opposition to Facebook's regulations.

It is important to consider that the primary goal of data mining companies, especially those that resell user information to marketers, has always been to achieve a vernacular reach: the thirteen-year-old meme admin is as important as the horny dad serial-liking *Maxim* articles, as both are capable consumers. So, even if Instagram's initial intent was to bolster user creativity, facilitating the means for a specific user to have an individual identity is a minuscule component of the Facebook experience when compared against the profit potential of the community as a whole.

On Facebook, a user's content becomes more valuable if it is able to pinpoint that user into a more specific market demo-graphic, as determined by their individual choices. This is why Facebook users are prompted to include social indicators on their profiles, like their gender, sexual orientation, religion, political affiliation, place of employment, and cities lived in. In providing Facebook with personal details, users are in turn rewarded with more friend recommendations, heightened visibility, and, subsequently, attention—a seemingly fair trade for the system's ability to position and target them accurately.

In terms of what gets censored, all users who break the rules are equally subject. In 2014, recording artist Rihanna's Instagram account was temporarily shut down by the platform's algorithms—much to her fans' outrage—after she self-published revealing photographs of her backside. Meanwhile, her record label Def Jam actively monetizes her often demure appearance through ad-integrated video content, specifically via the Google-owned hosting service VEVO, which is disseminated by YouTube and out-linked to the corporate Facebook pages of their artists, Rihanna included. By limiting Facebook's prospect of yielding earnings from Rihanna's sex appeal, the platform's algorithms saw little incentive in encouraging her self-expression. This example points to an obvious contrasting principle: while individuality may be in jeopardy, branded, billable content almost never is.

Facebook already knew that I would be an ideal user of THINX's product. Perhaps it is my prime childbearing age, 28, or the fact

that my profile indicates I'm a cis woman. Perhaps it's because I live in Brooklyn, enjoy the occasional noise show, and have once seen an episode of *Girls* that my account screams: "this user is alternative and will most likely appreciate the campaign's feminist undertones." I'm not sure how specific Facebook's psychoanalysis is, but all manners of my research have indicated that, whatever the process, it's creepily accurate.

If Kaur's images had been part of THINX's campaign, would they still have been flagged? American First Amendment attorney and anti-censorship advocate Lawrence G. Walters believes that censorship, especially online, has become fully privatized; as he wrote in an online article on the subject: "With no constitutional restrictions to rein them in, giant, multi-billion-dollar companies end up making critical decisions on what content the general public can see, read, and hear. The corporations making these decisions are now more powerful than most countries, at least when it comes to being the gatekeepers of communication." Walters continues by insisting that the only way to avoid censorship is to align your content with the social media network least likely to censor it.

Yet self-selecting to evade censorship isn't the only solution; users must demand that corporations like Facebook better consider their social motivations—those beyond their ties to consumerism. An important point to raise is that all technologies, digital or otherwise, will always be coded by the biases of their creators. To date, Facebook has been unable to design algorithms that are impartial to the corporation's morally conservative agenda. Perhaps the only way to promote self-expression, removed from profit, is to change the platforms' flagging systems from the ground up. This could mean developing algorithms that are, quite literally, trained to be more understanding of women who bleed.

Alexis Anais Avedisian is a writer invested in topics including social media theory and Internet art. She holds a Master's degree from NYU Steinhardt, for which she wrote her thesis on new forms of cyberfeminist activism. She is the current Communications Manager of NYC Media Lab, a public–private partnership launched by the New York City Economic Development Corporation, Columbia University, and New York University working to foster collaboration across a range of technology and digital media disciplines. In the past, she worked in the Office of Communications at MIT's School of Architecture and Planning, at Rhizome as an Editorial Fellow, and as a contributing writer to Art21 Magazine. *Her Twitter username is @holyurl.*

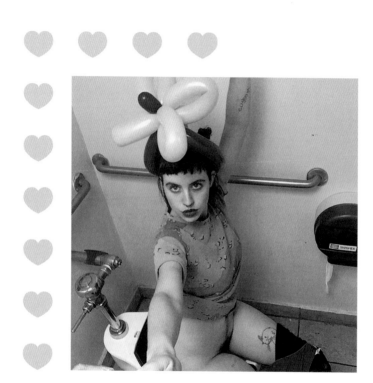

@bloatedandalone4evr1993

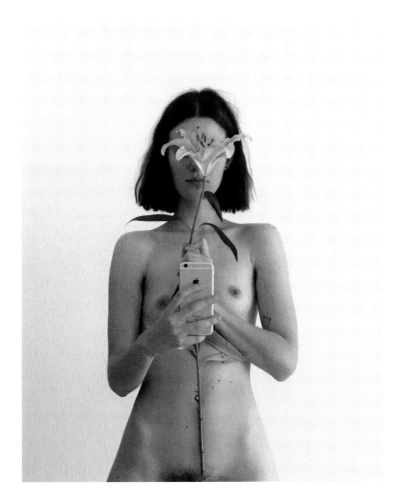

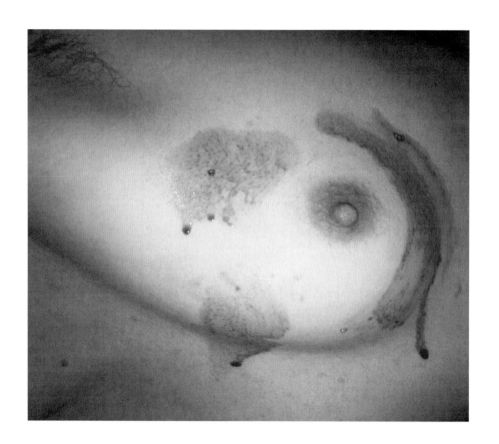

@yultaalol

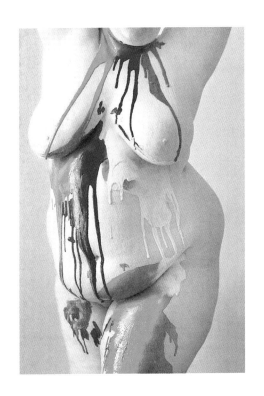

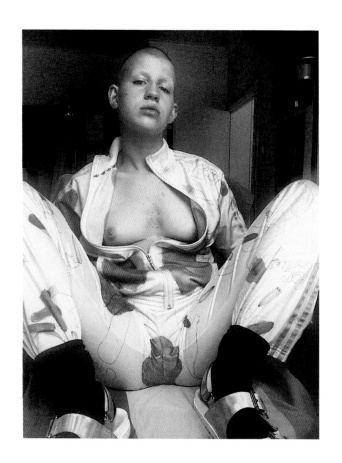

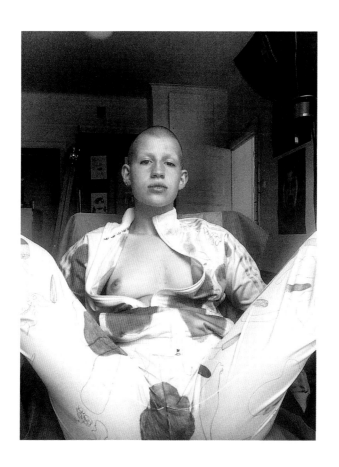

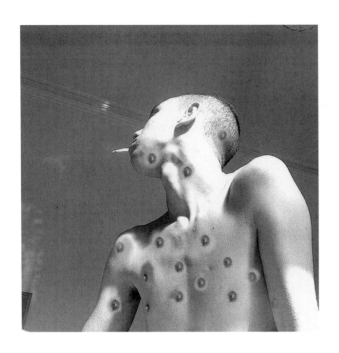

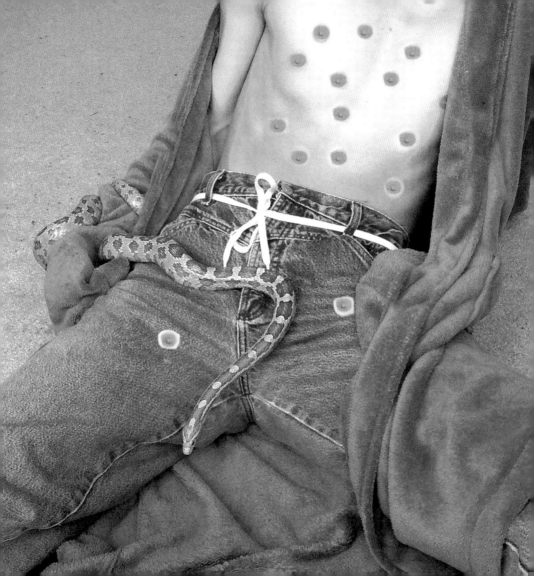

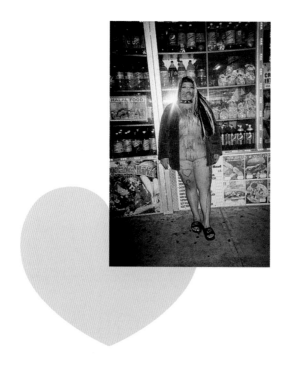

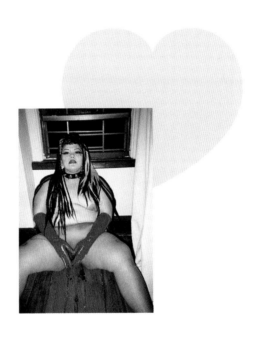

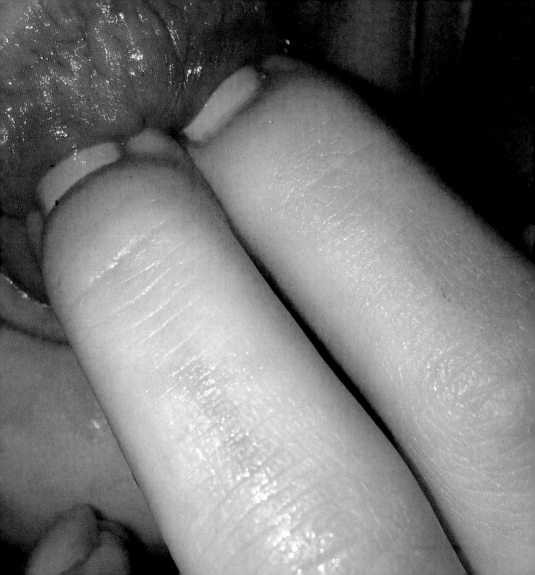

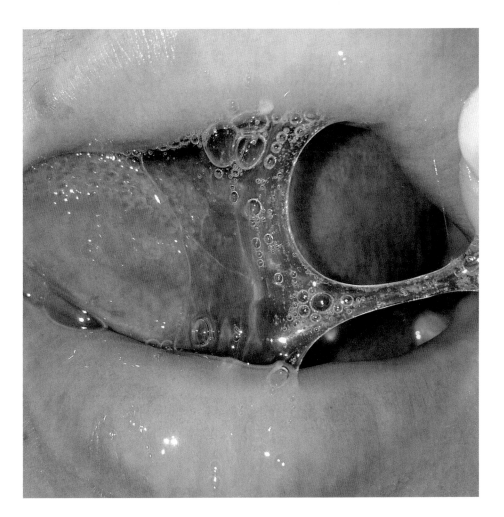

@powerpuffb1tch

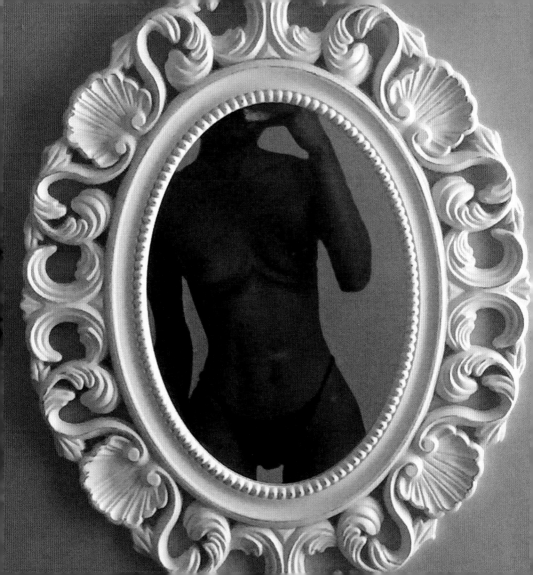

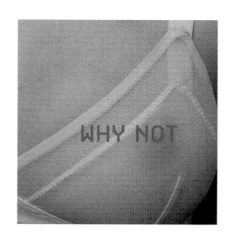

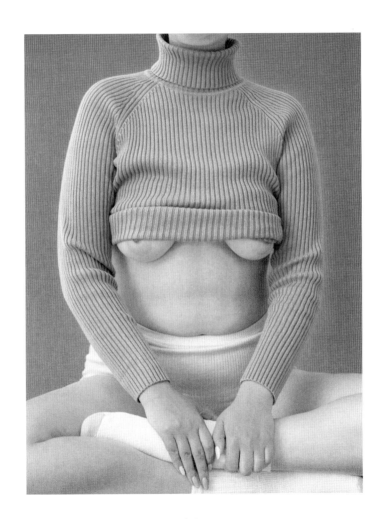

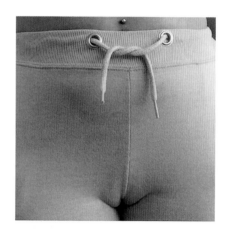

@habitual_body_monitoring

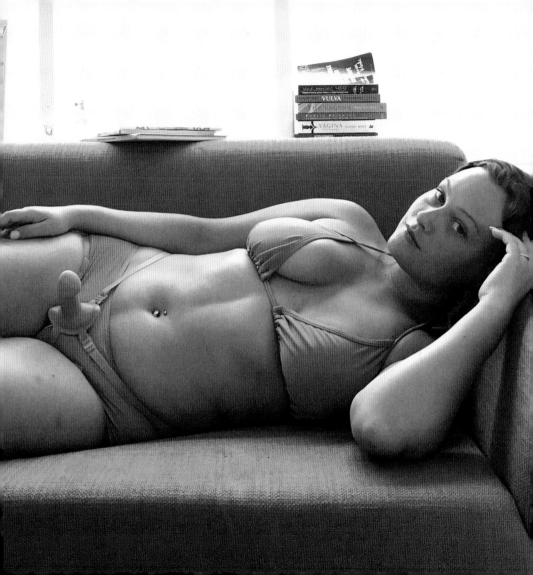

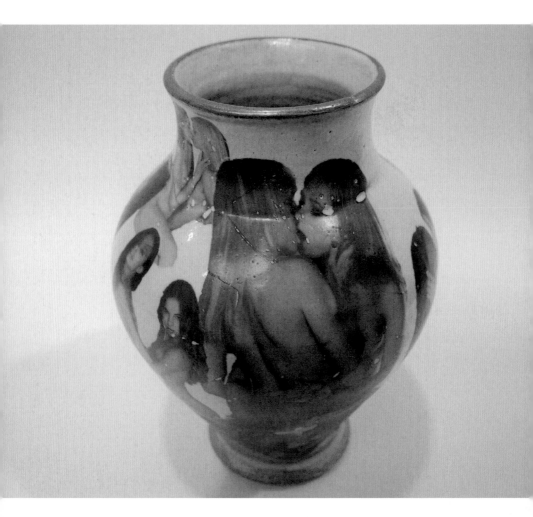

@georgiagracegibson

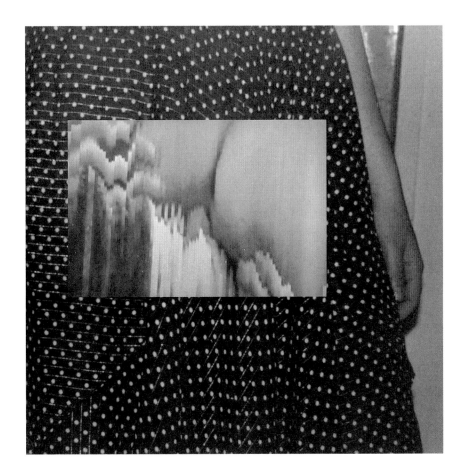

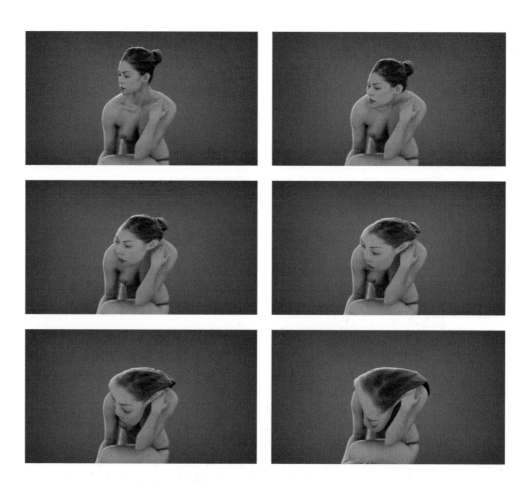

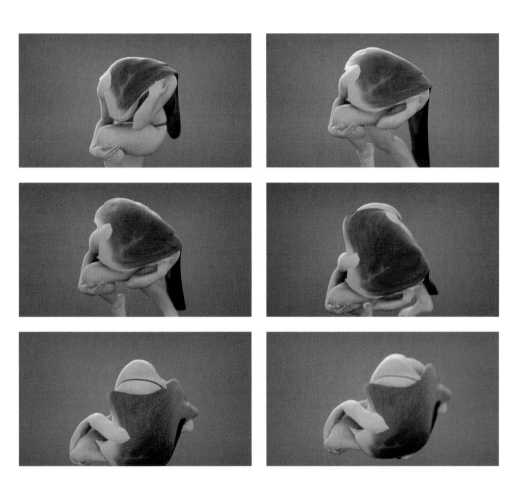

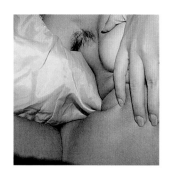

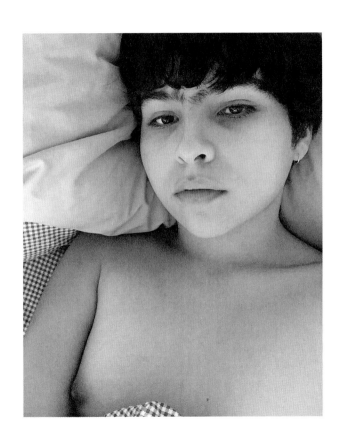

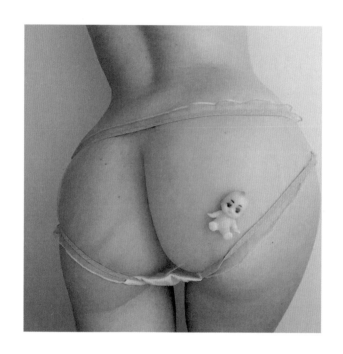

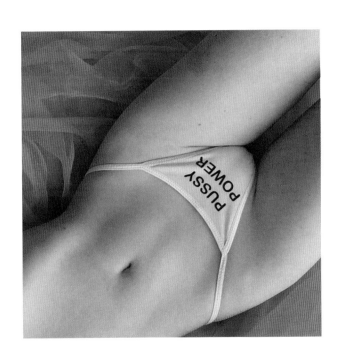

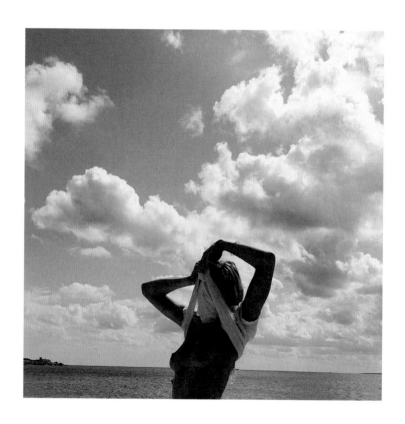

@beyonceborje

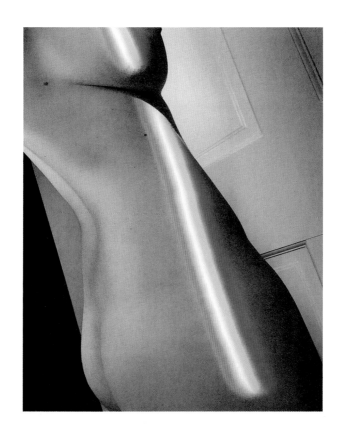

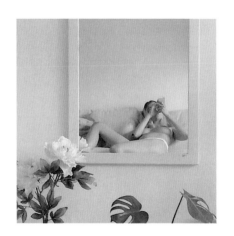

@verajorgensen

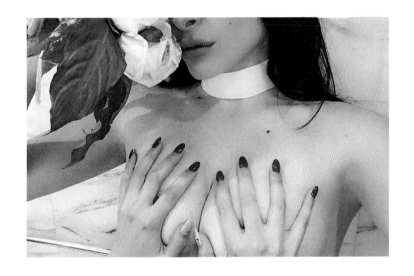

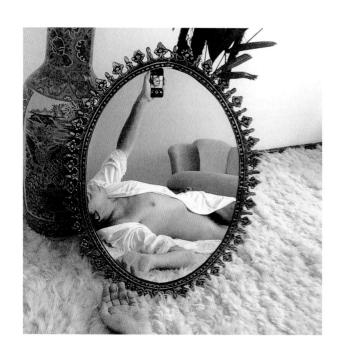

@moonriverchacha

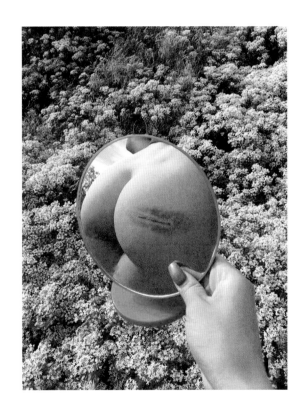

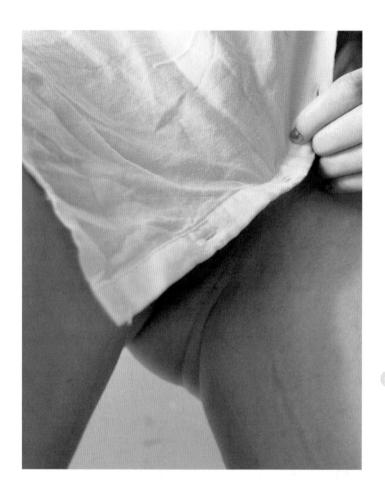

@juliana.maar

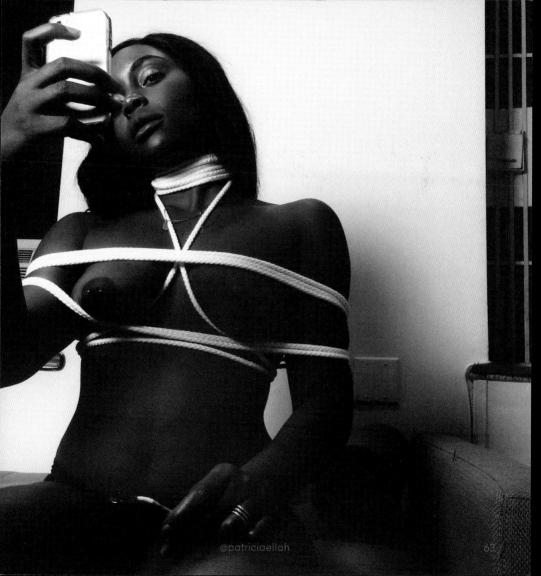

@patriciaellah

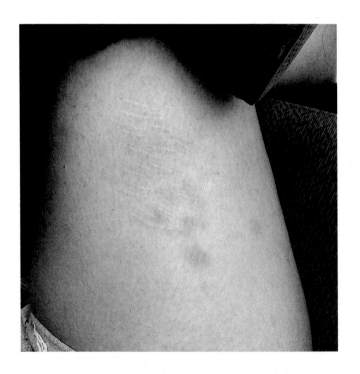

@kaylaxcombs

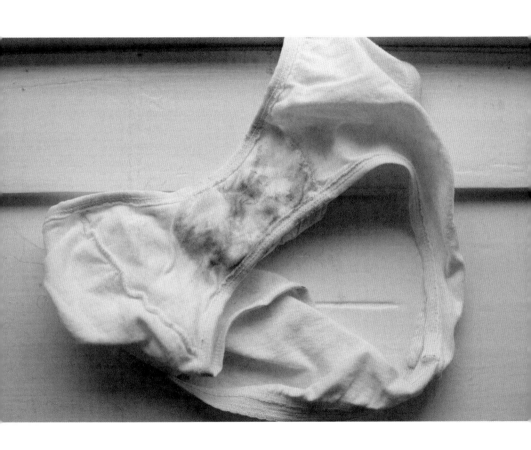

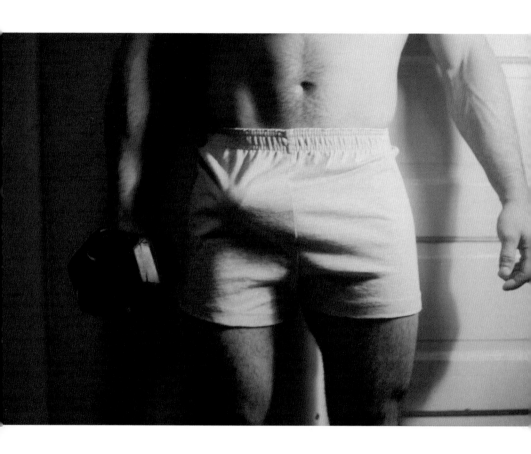

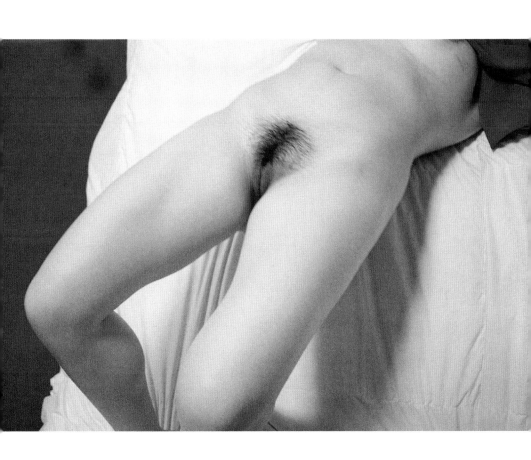

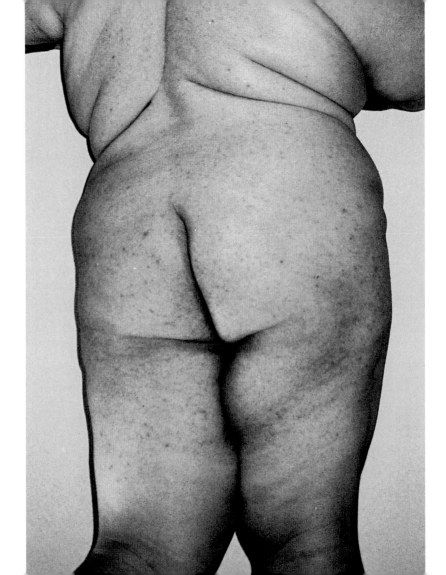

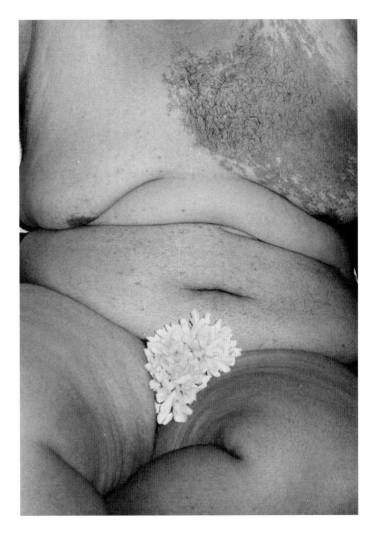

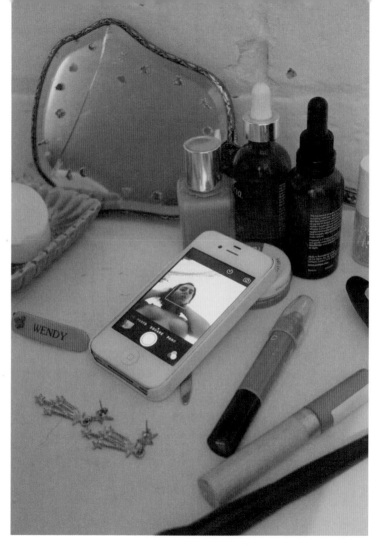

@show_you_mine

@reuelklara

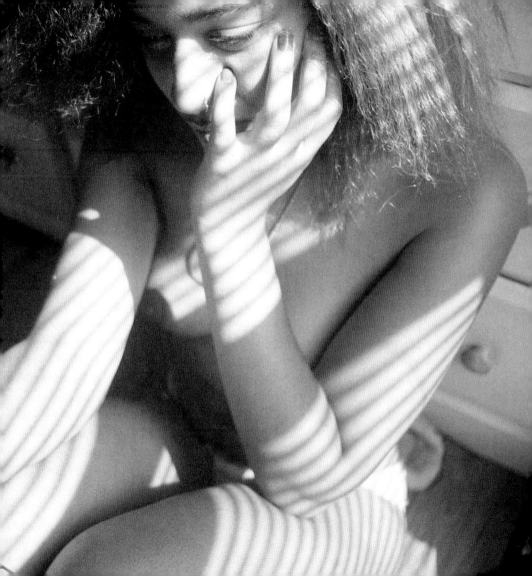

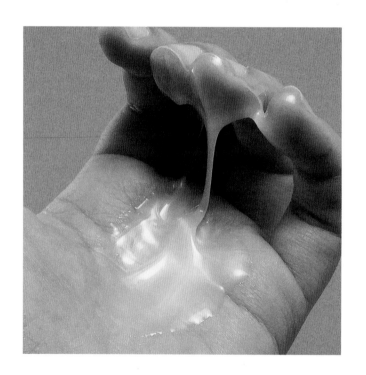

@alexxalopezz

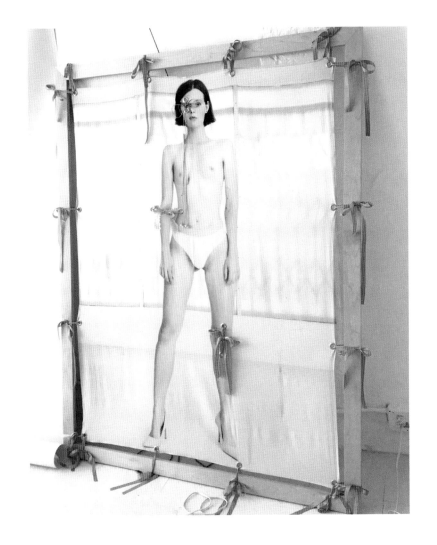

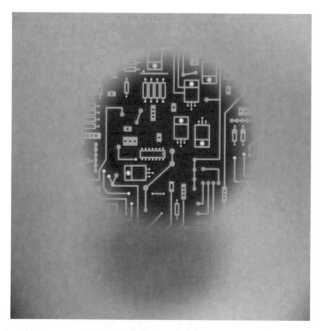

@themediawitch_

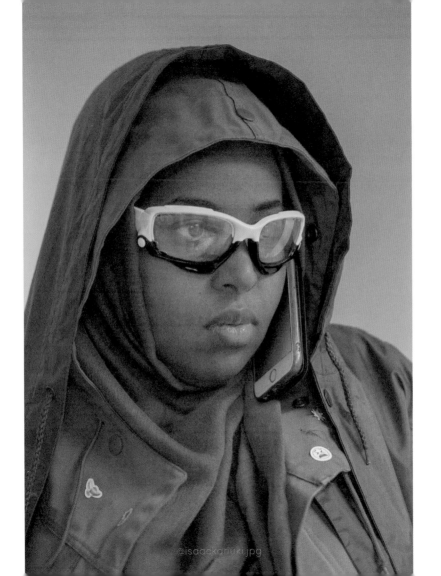

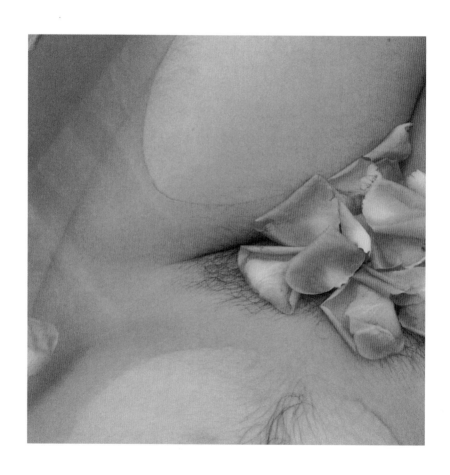

@aceofcups

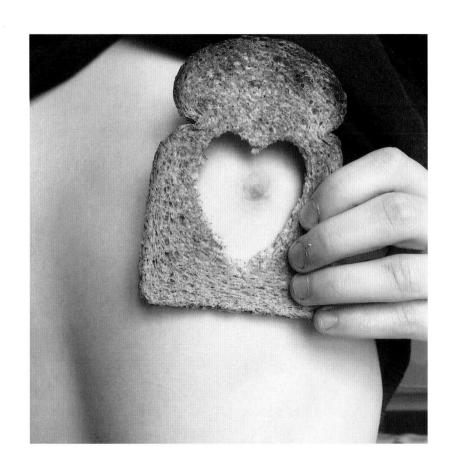

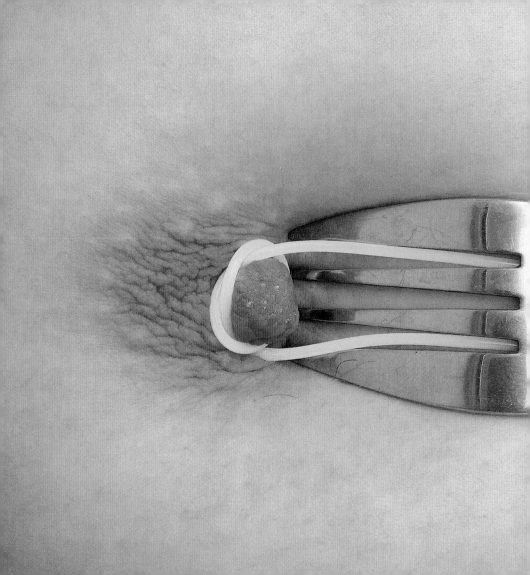

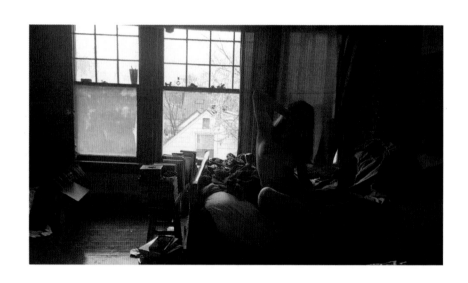

@anonymous

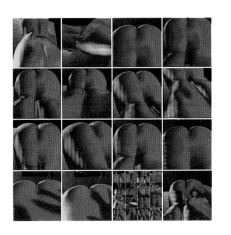

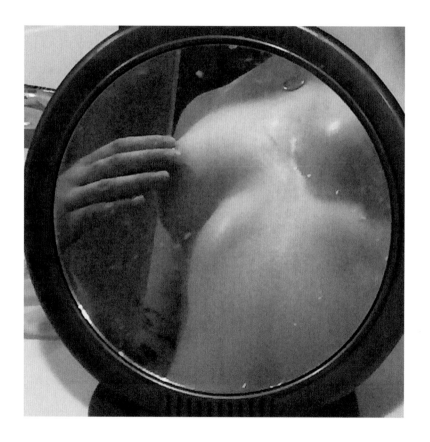

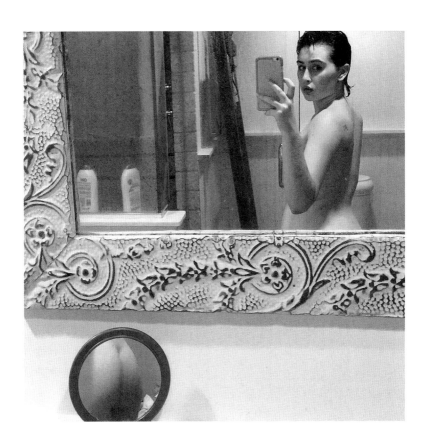

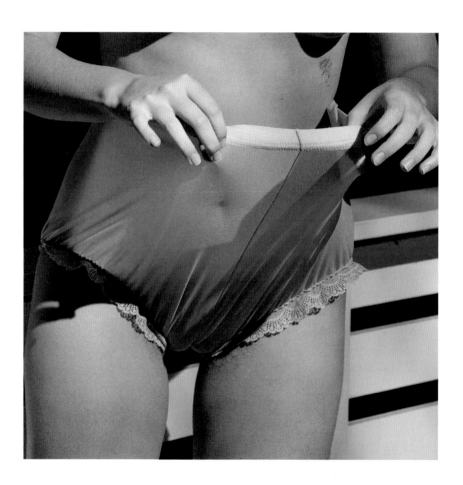

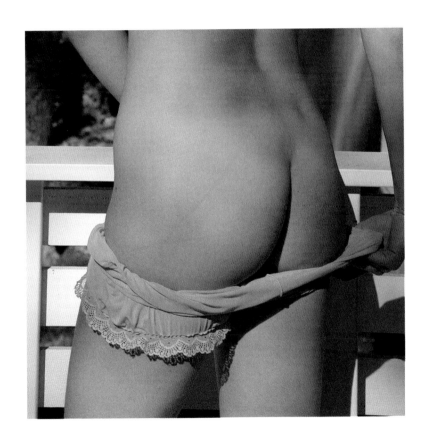

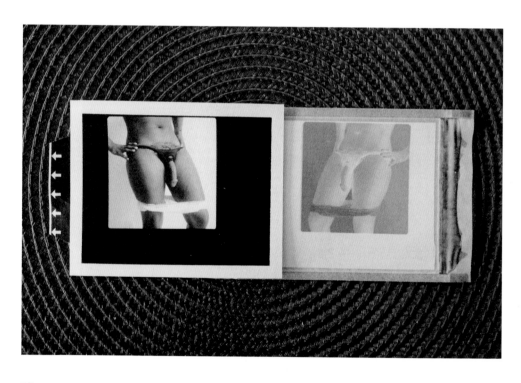

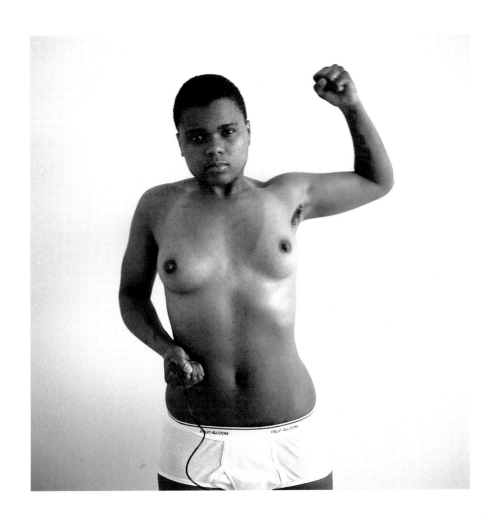

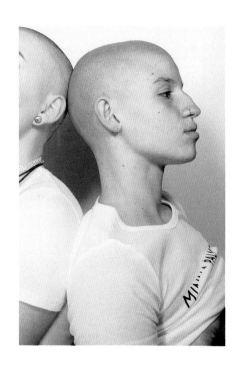

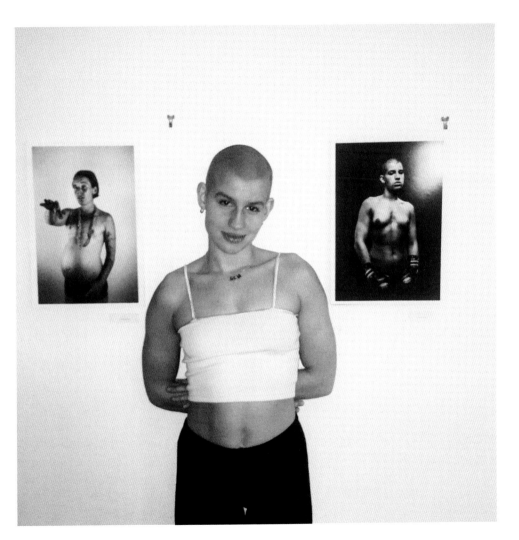

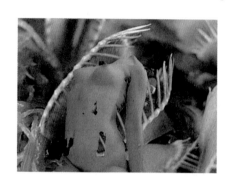

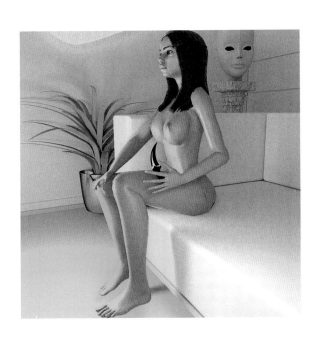

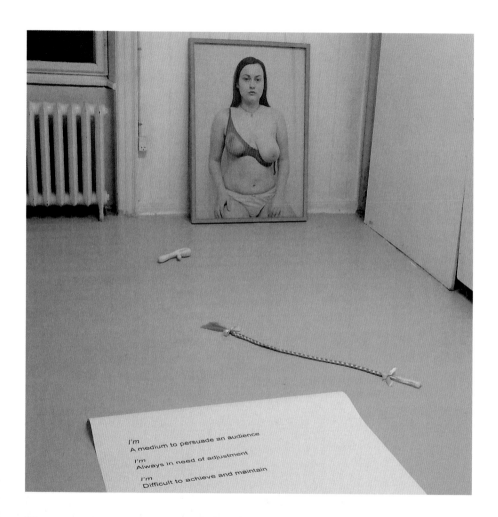

I'm
A medium to persuade an audience

I'm
Always in need of adjustment

I'm
Difficult to achieve and maintain

@habitual_body_monitoring

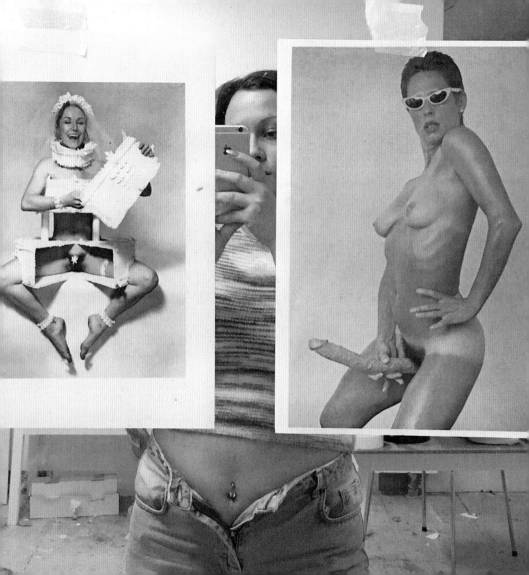

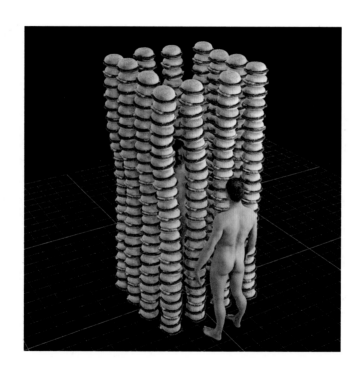

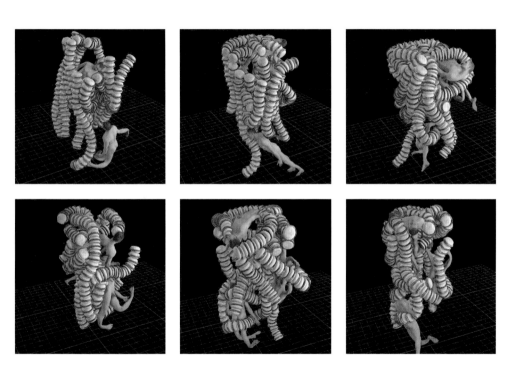

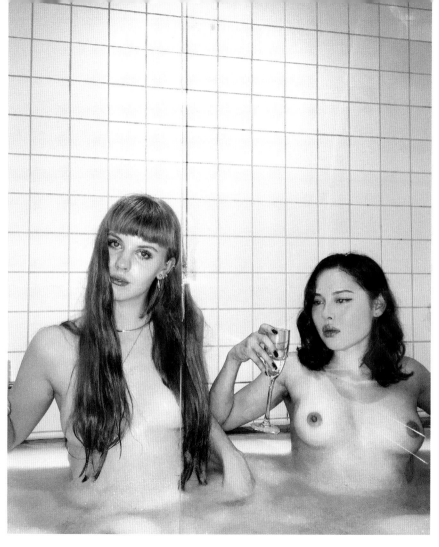

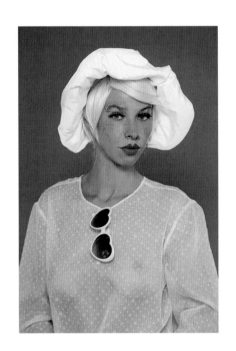

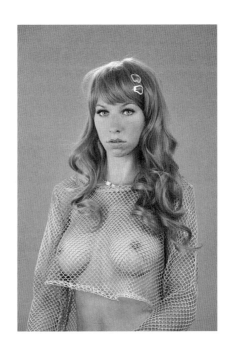

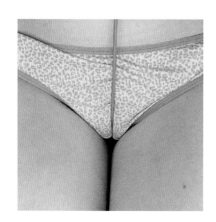

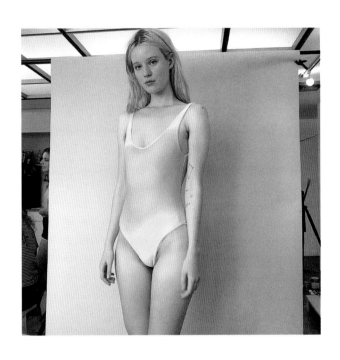

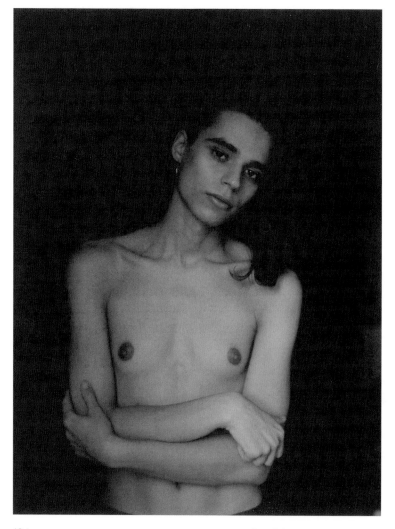

@massima.lei

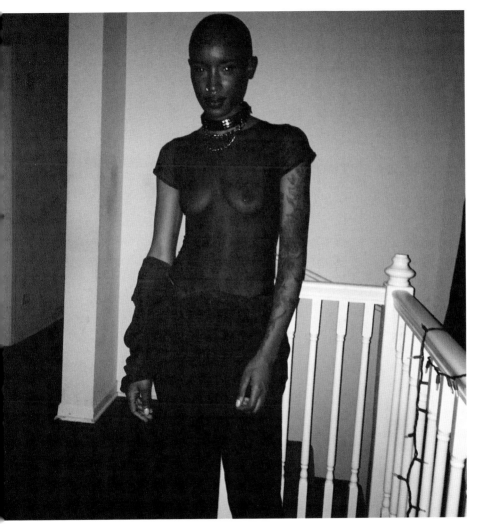

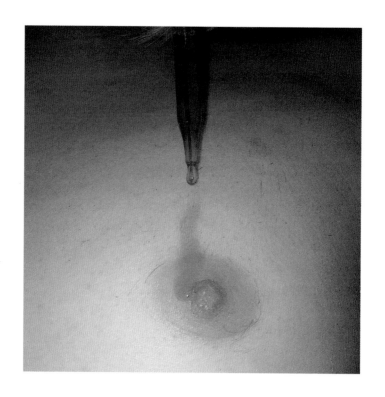

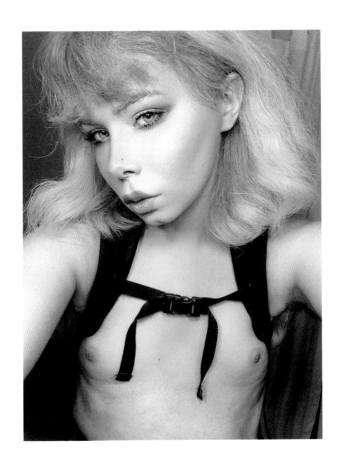

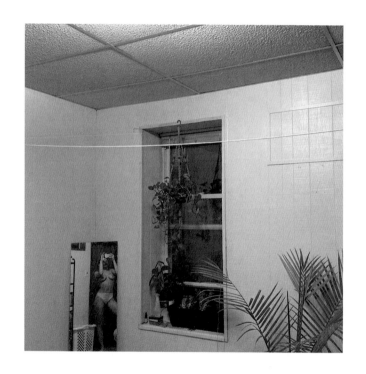

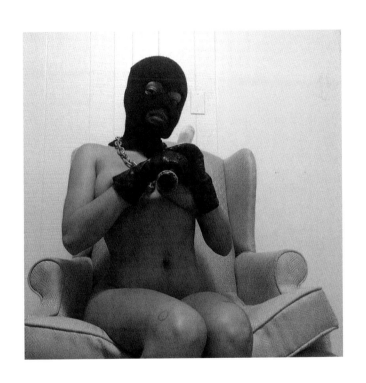

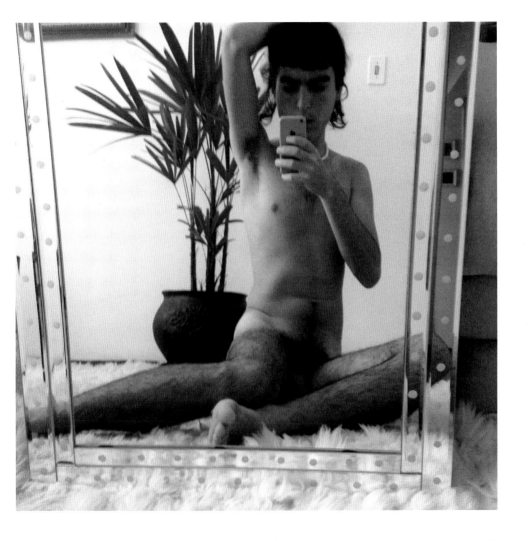

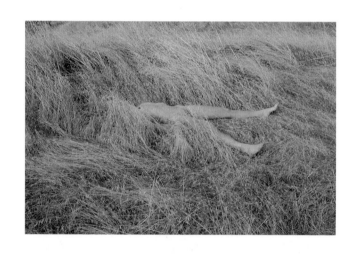

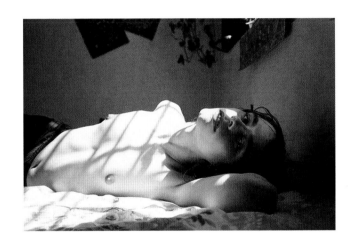

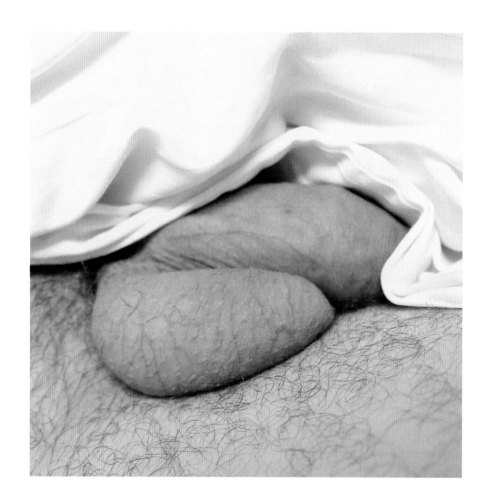

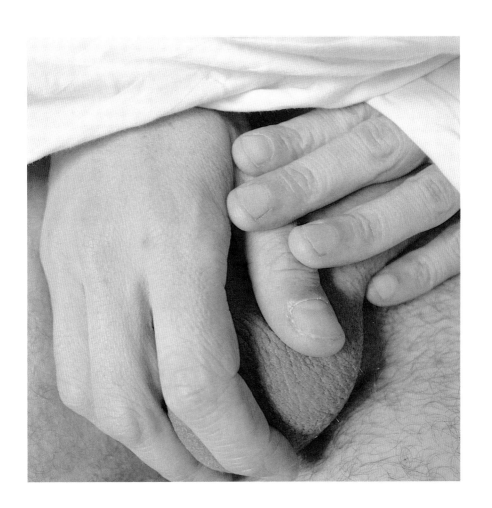

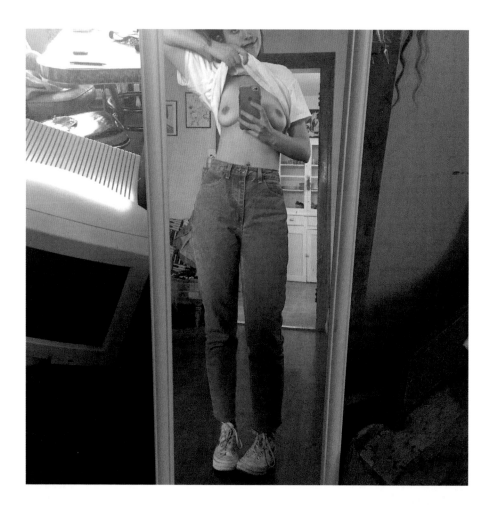

@bloatedandalone4evr1993

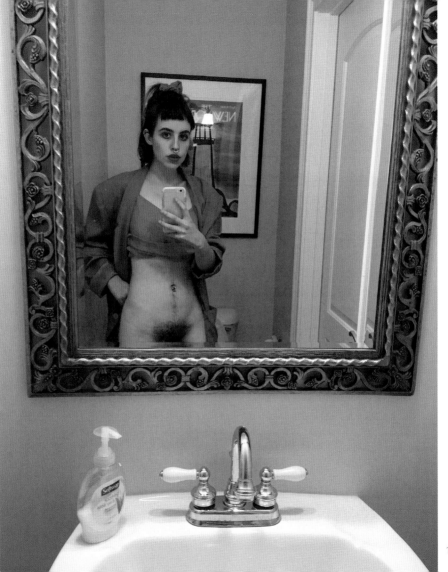

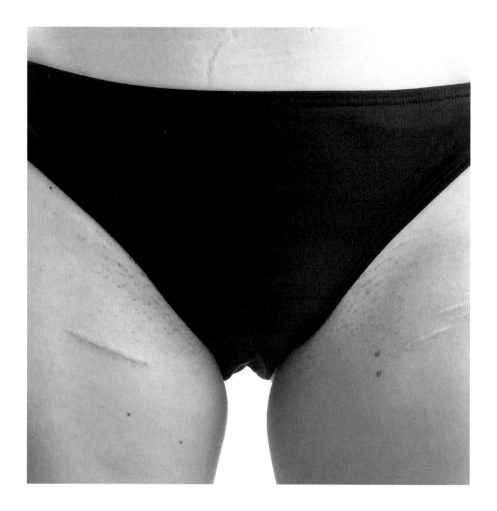

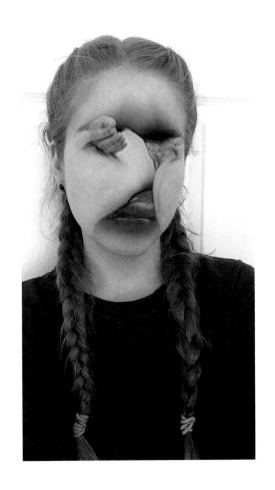

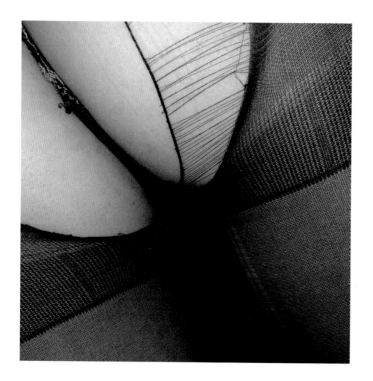

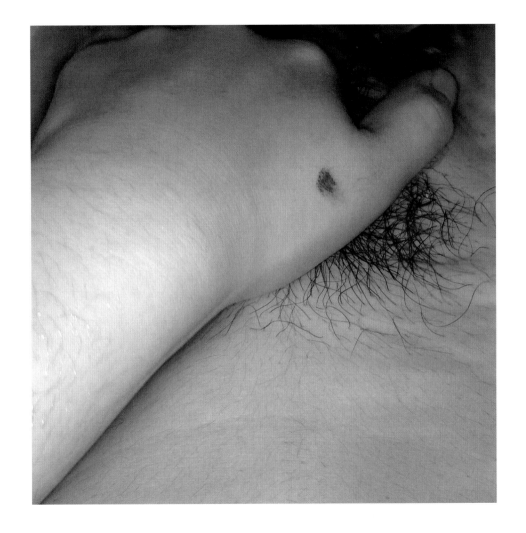

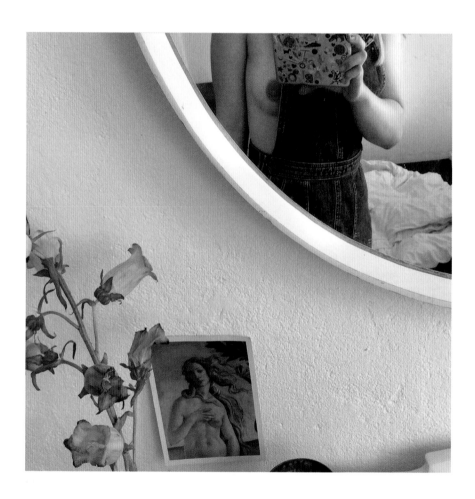

@_carlornd_

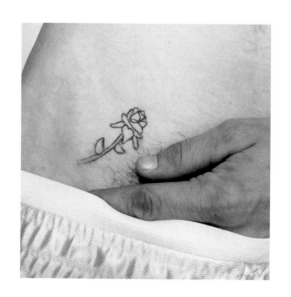

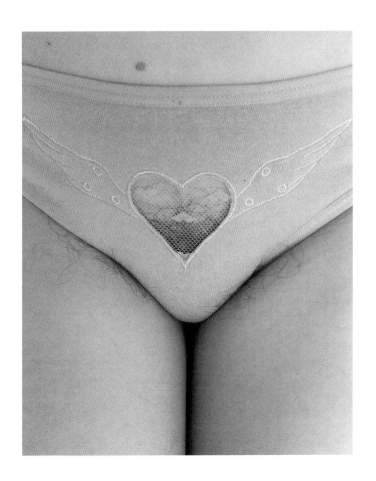

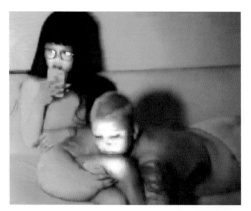
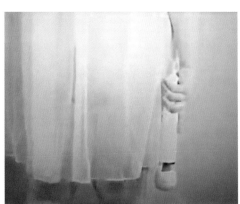
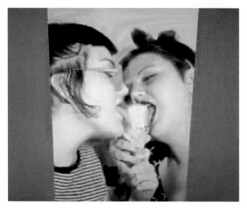
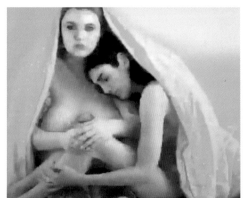

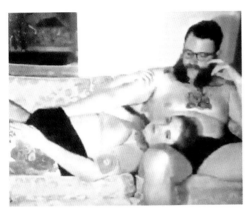
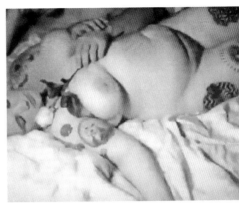
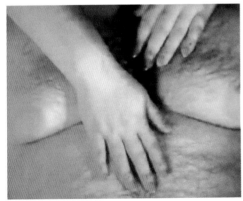
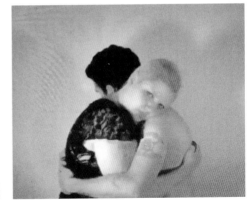

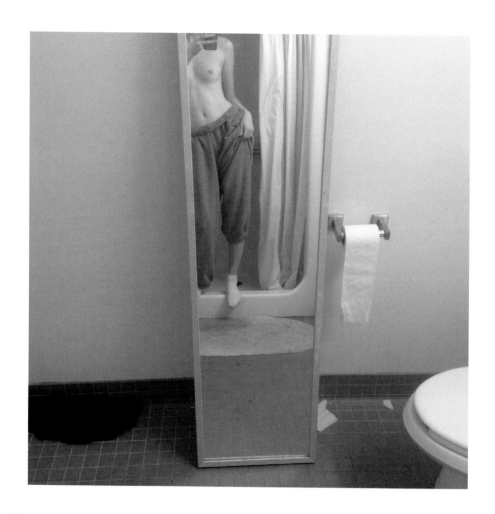

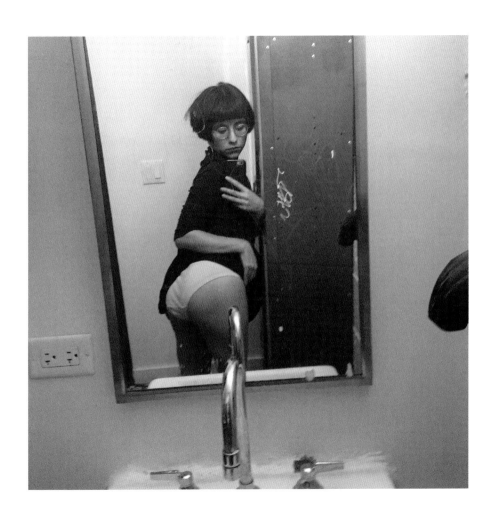

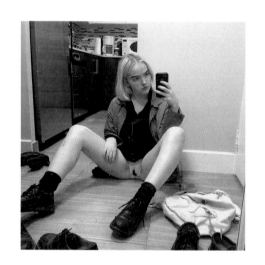

@sentient_meat

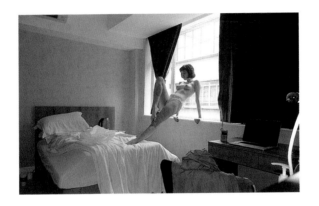

@amaliaulman

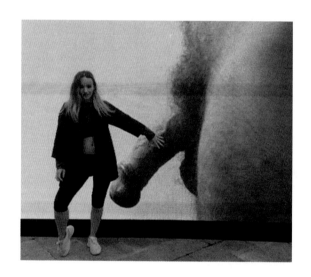

@expendable_limbs

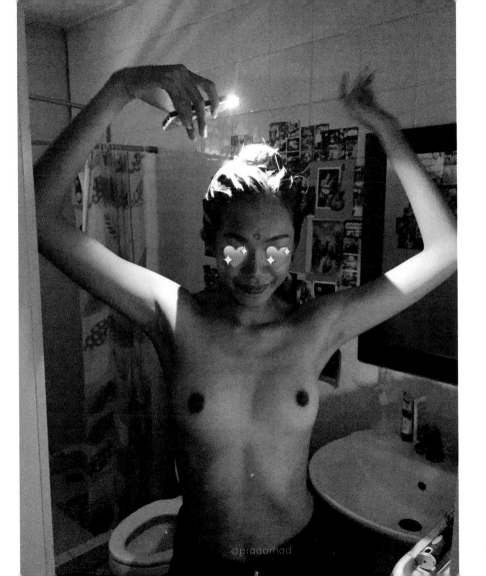

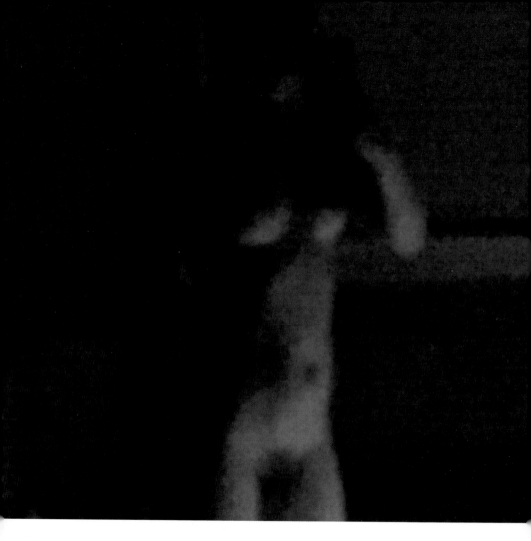

@bathingbeauty94

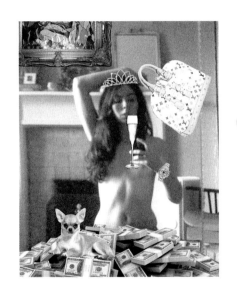

Today at 2:08 AM

 Can I fuck you on the hood of my dads car?!? lol

Do you want to let xavier_jbc send you messages from now on? They'll only know you've seen their request if you choose Allow.

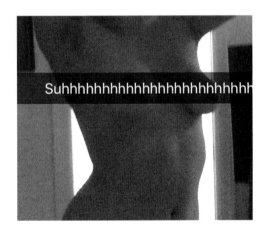

Suhhhhhhhhhhhhhhhhhhhhhhhhhh

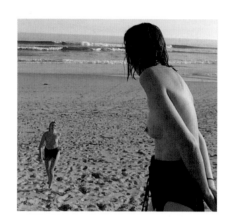

@tara_sian

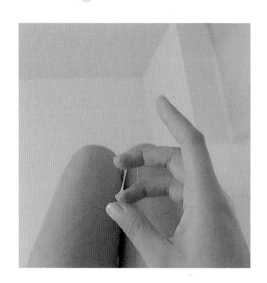

@anonymous

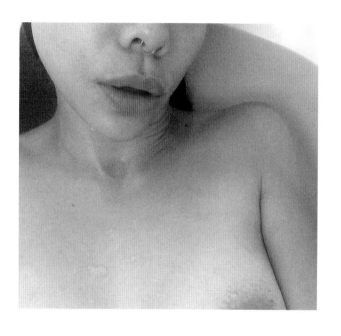

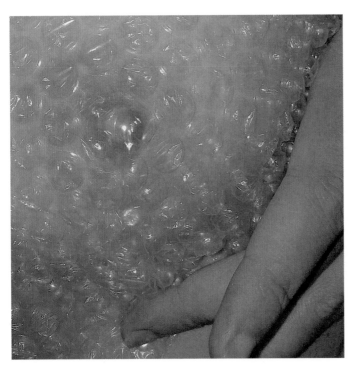

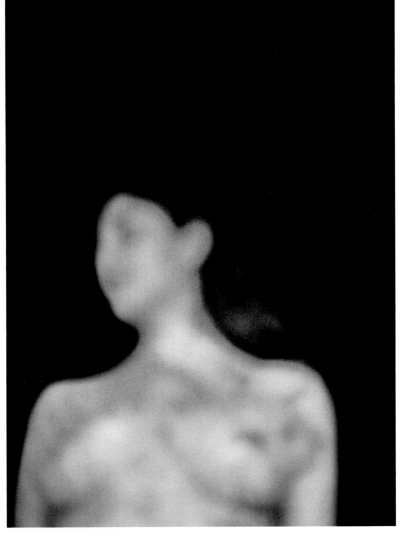

@babydreamgirl

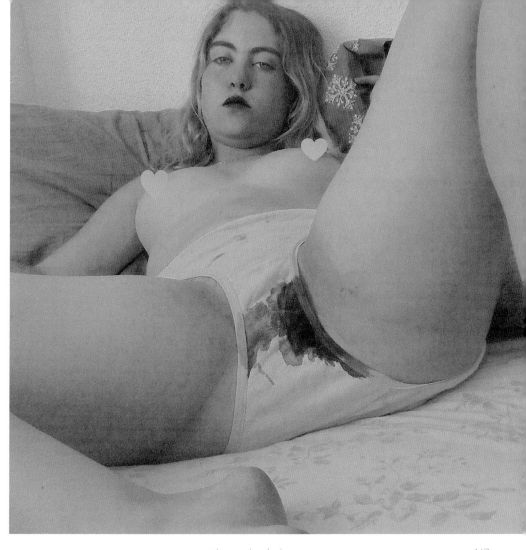

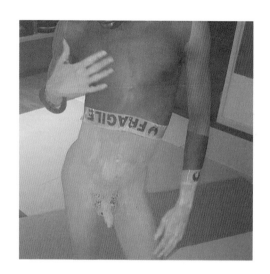

@zimbabwe700clubfoundation2019

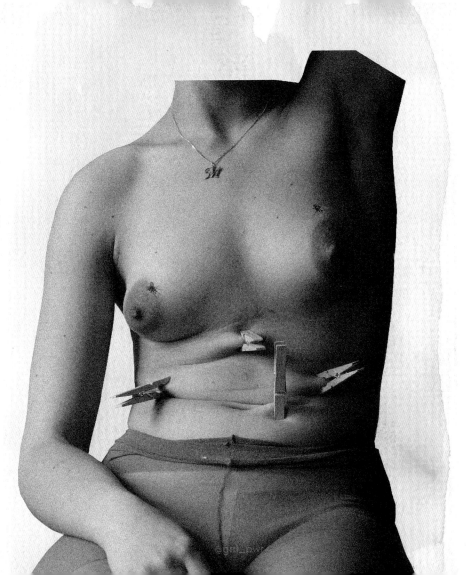

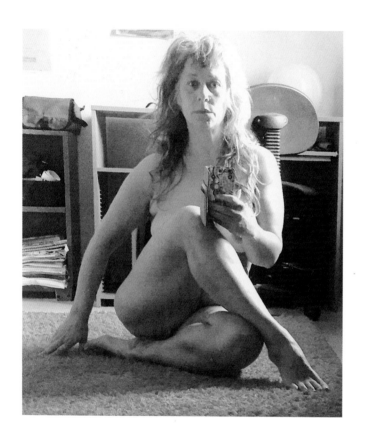

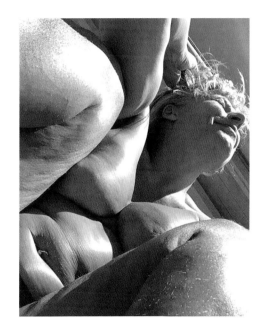

@flopsyflopsy

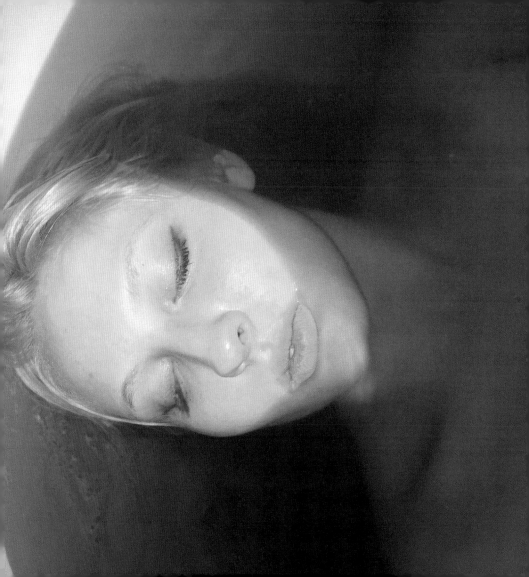

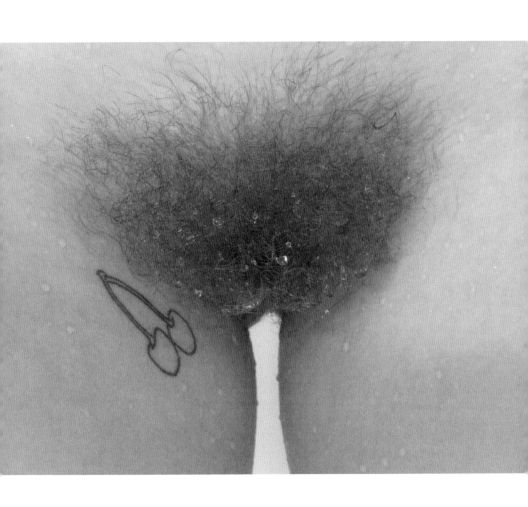

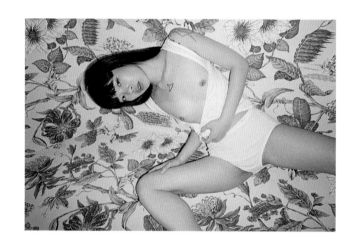

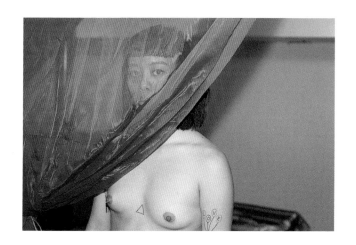

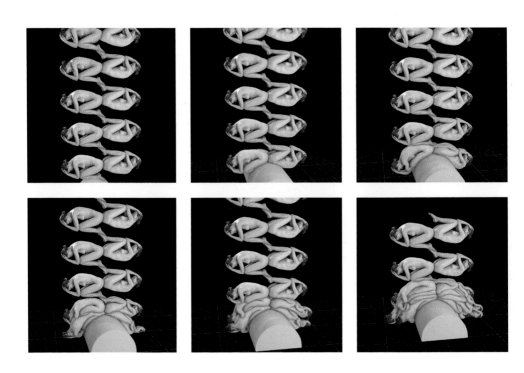

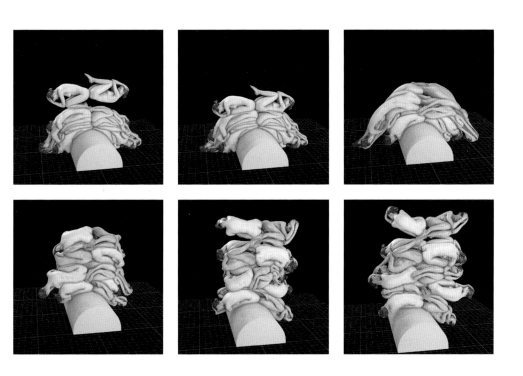

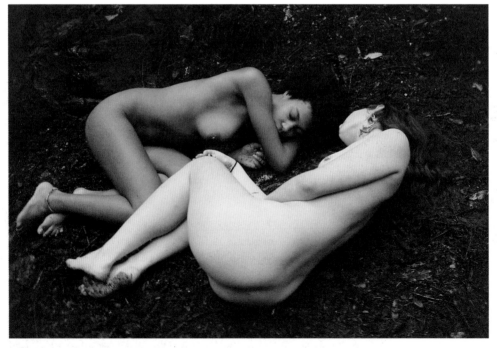

@littlesunlady

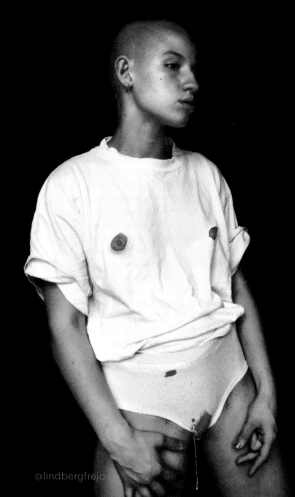

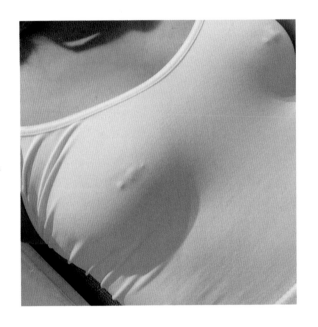

@j.k.houston

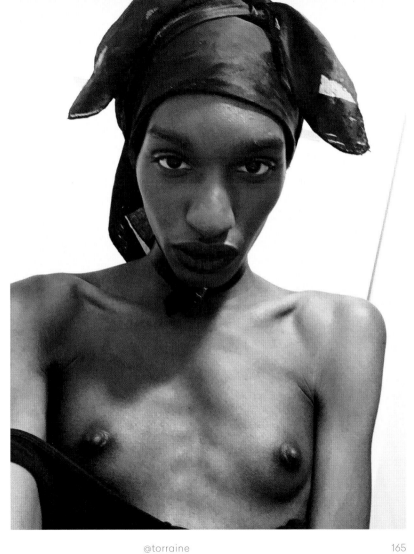

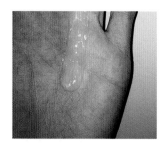

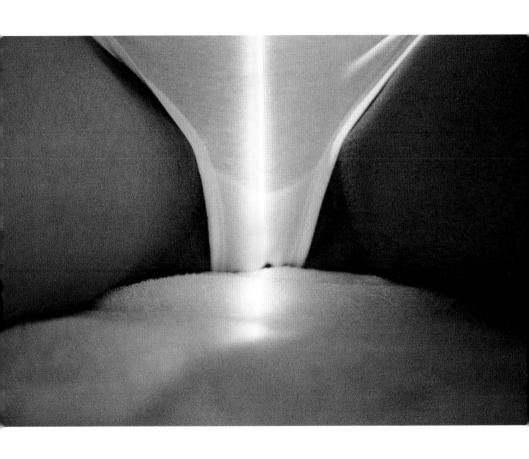

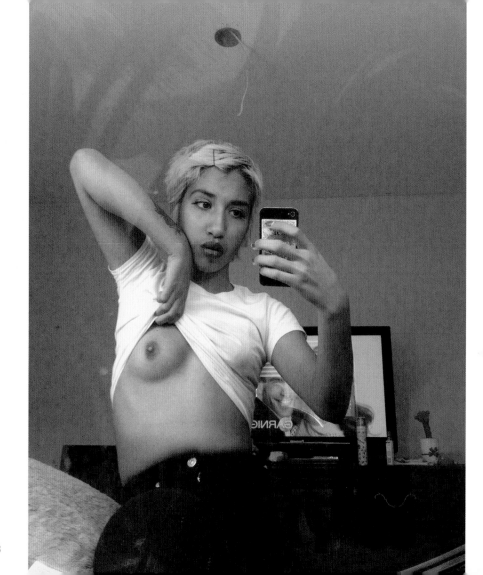

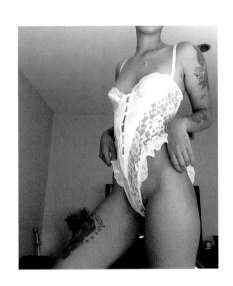

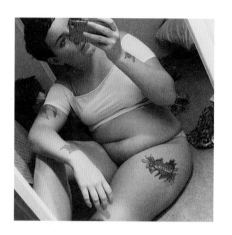

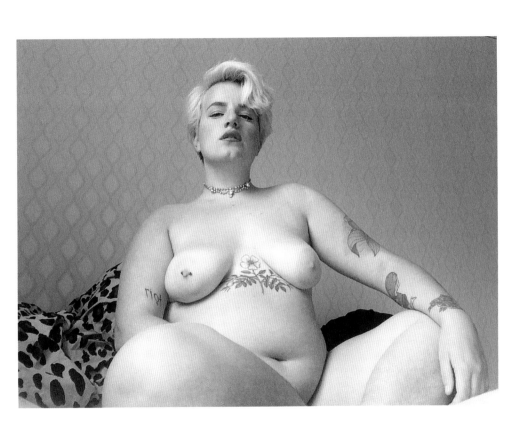

@babe_ebba

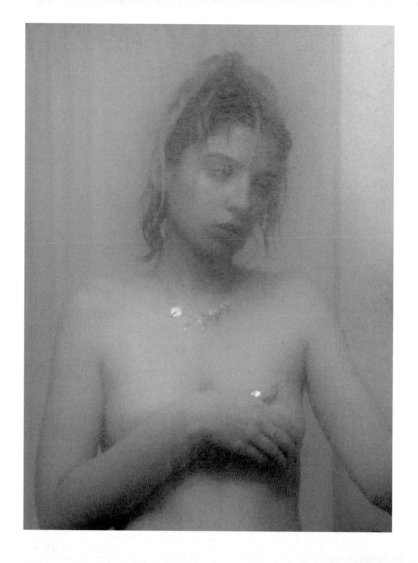

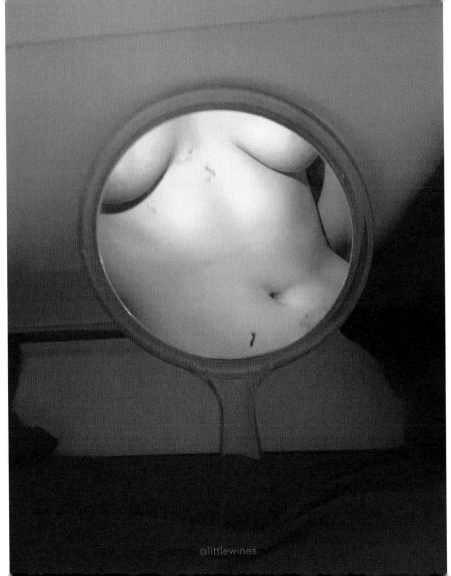

173

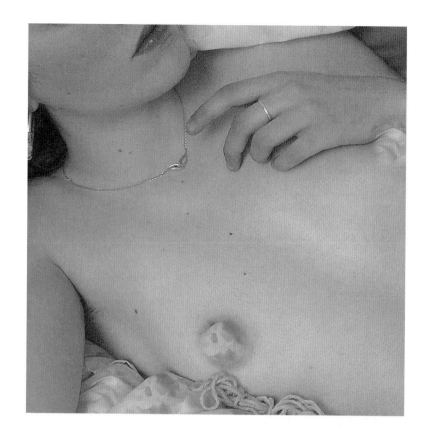

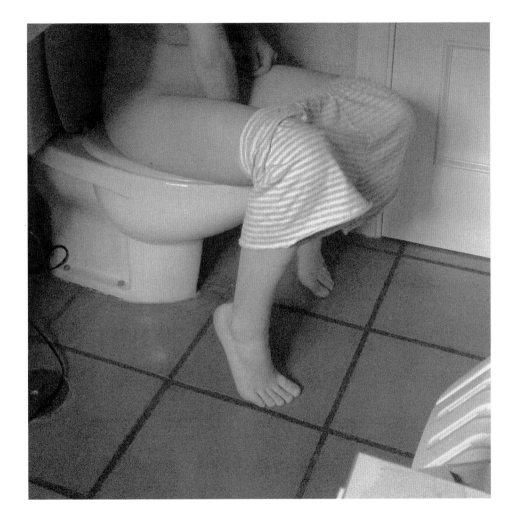

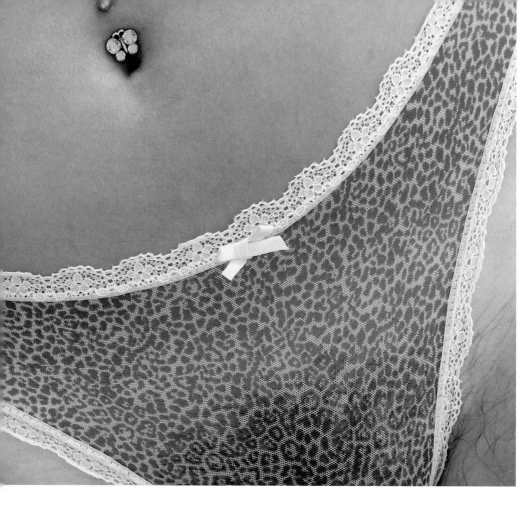

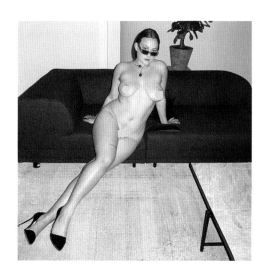

@smellslikeapricots

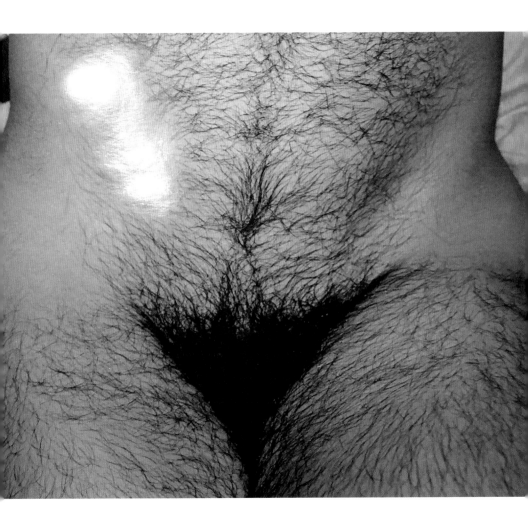

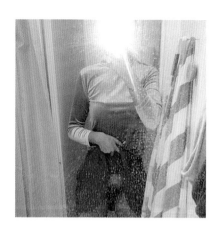

@the_irl_girl

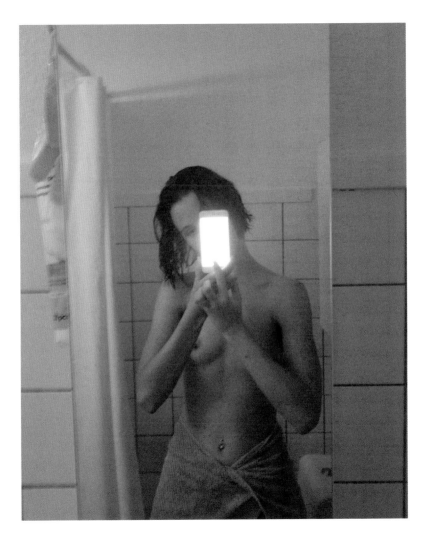

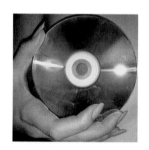

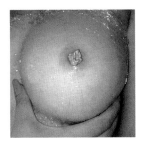

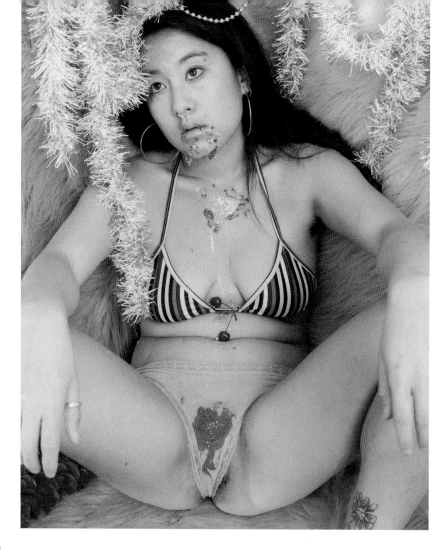

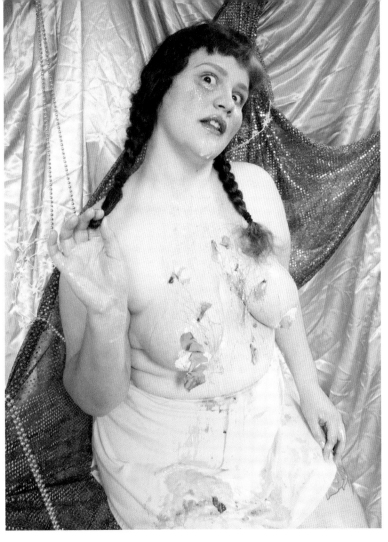

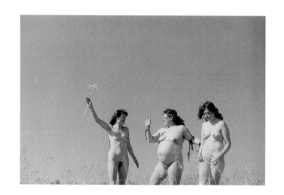

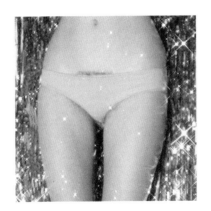

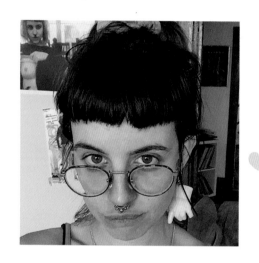

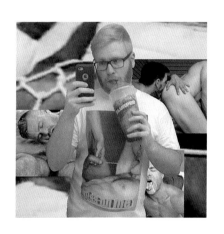

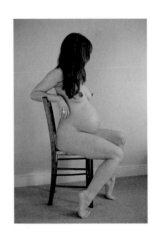

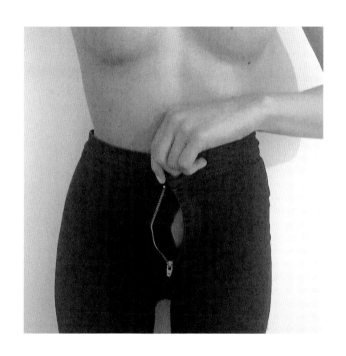

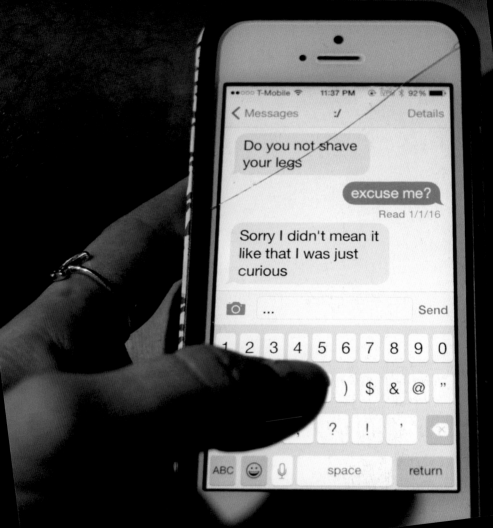

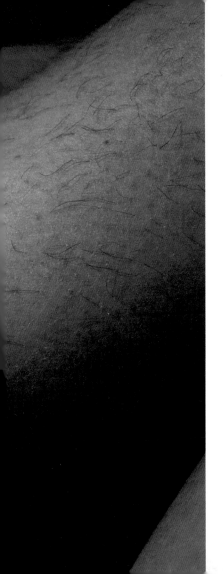

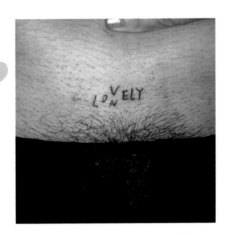

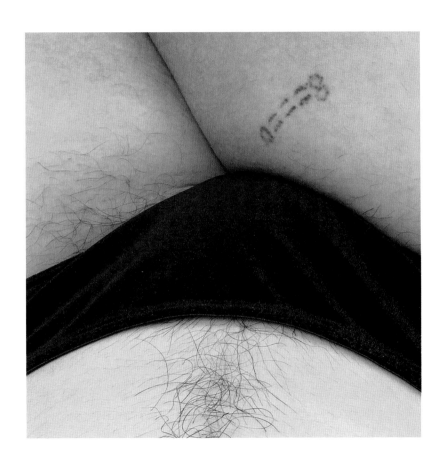

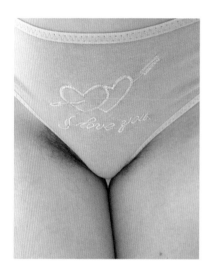

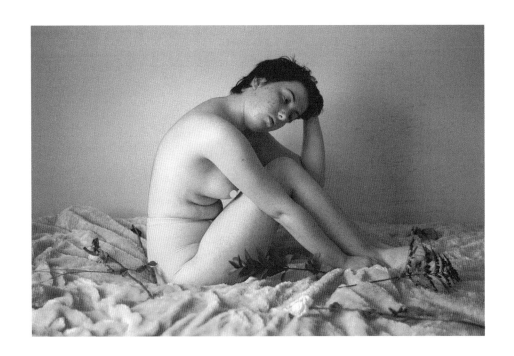

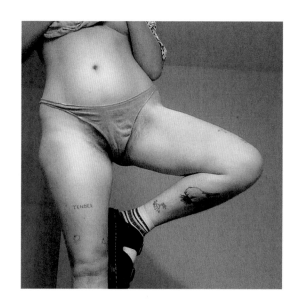

@dump_him

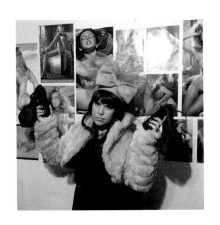

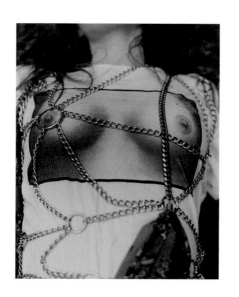

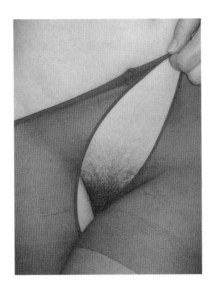

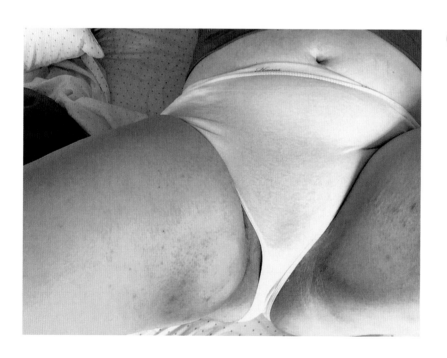

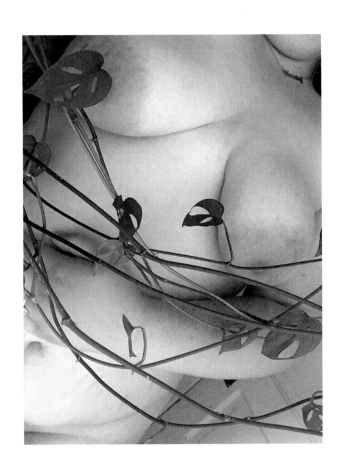

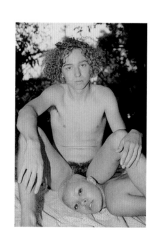

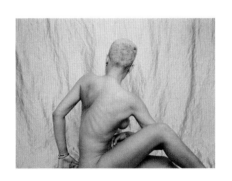

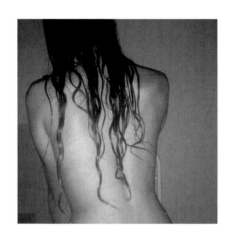

@anonymous

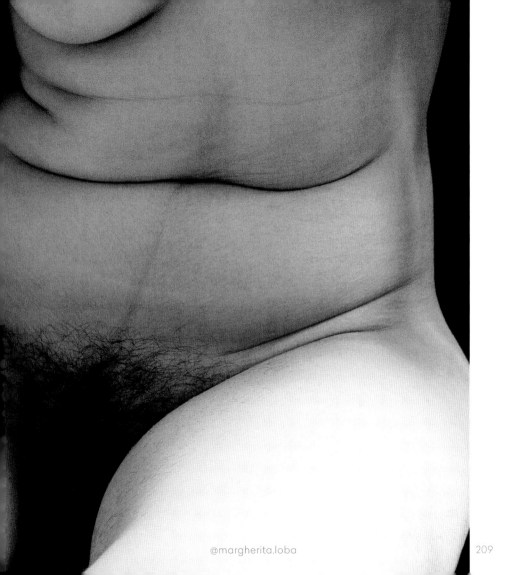

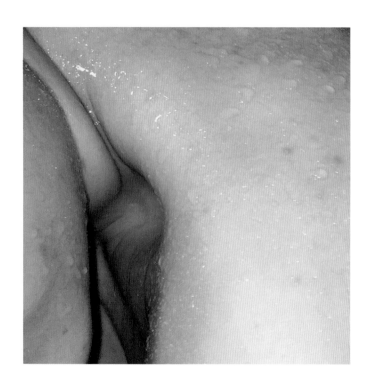

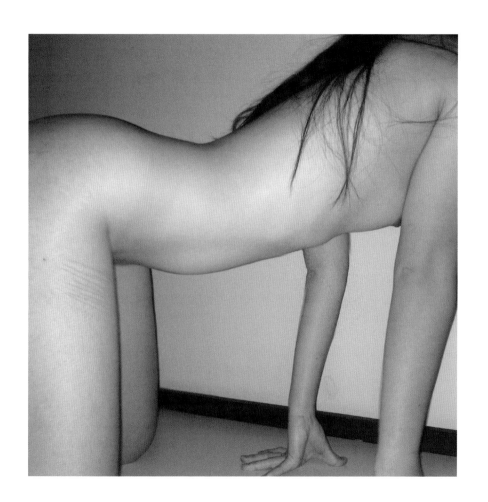

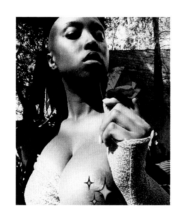

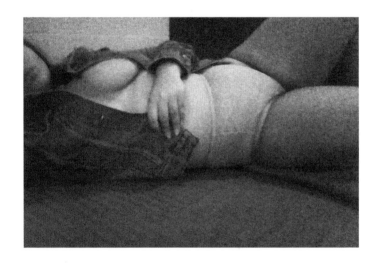

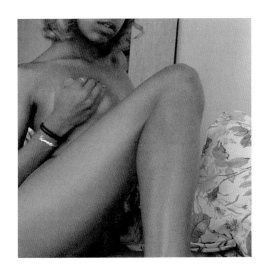

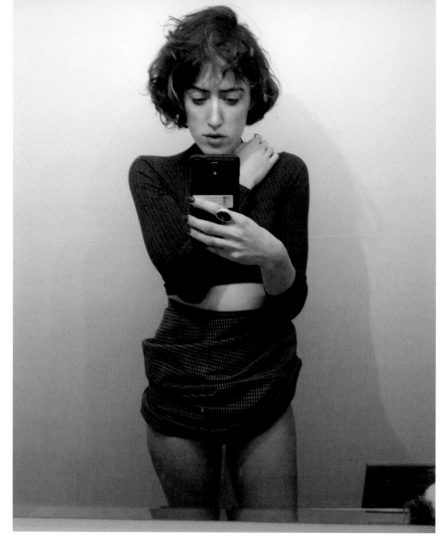

@arguingforfun

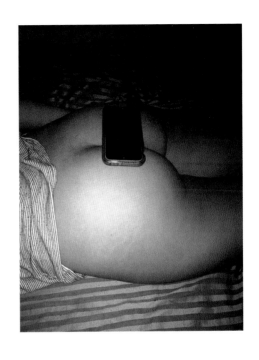

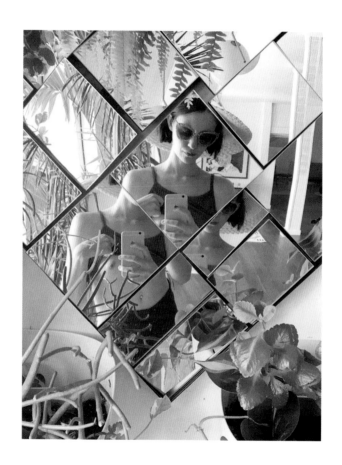

@arvidabystrom

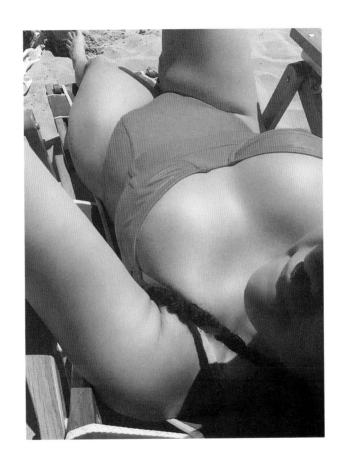

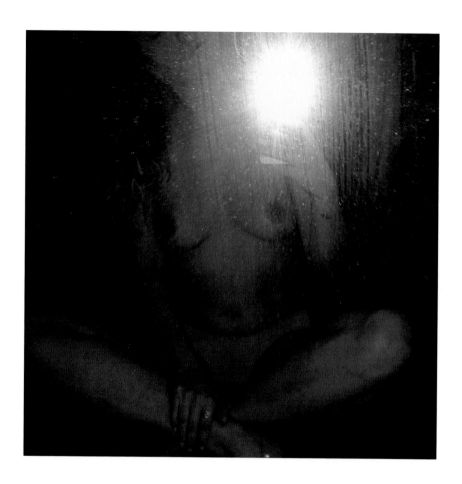

@the_irl_girl

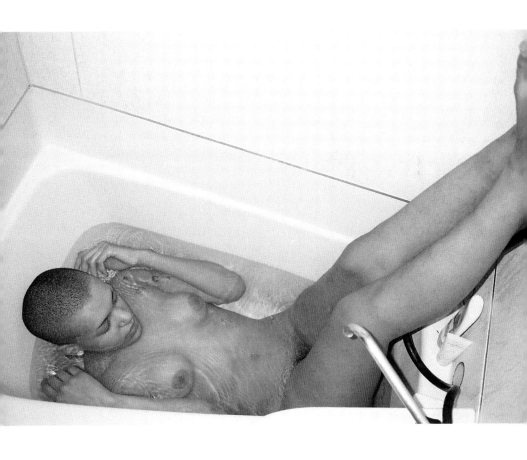

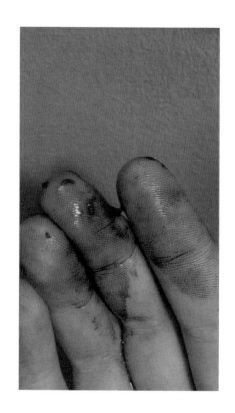

@lollywell

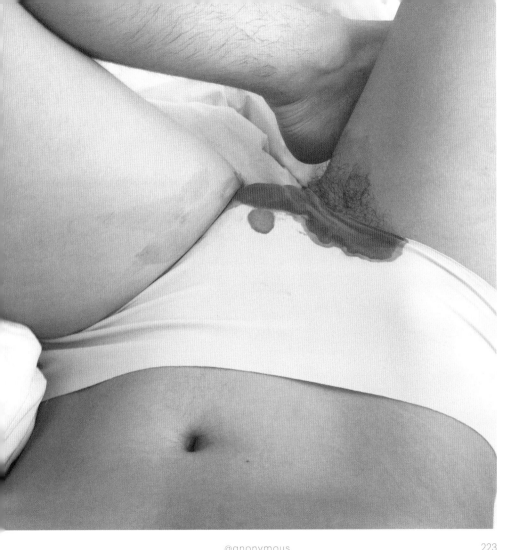

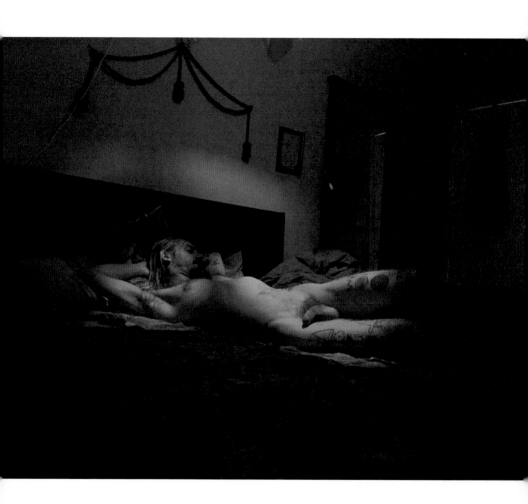

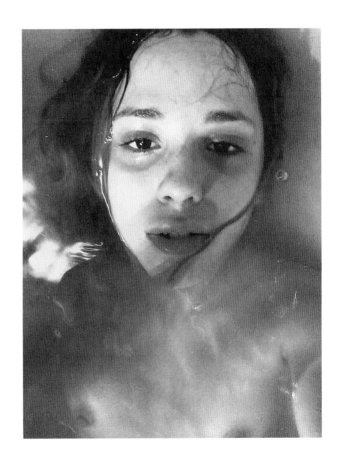

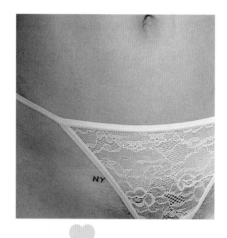

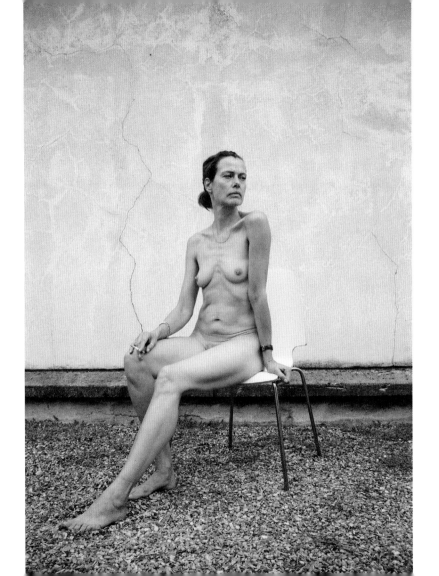

@somethingfunctional

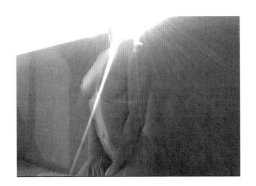

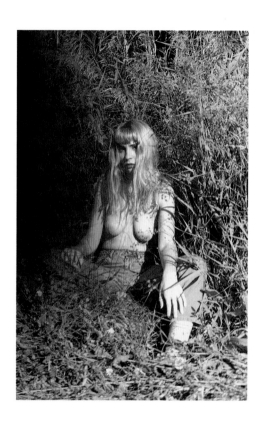

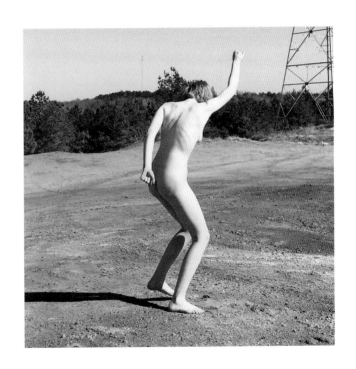

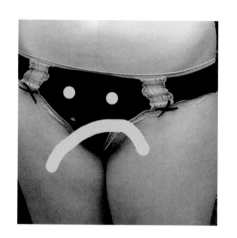

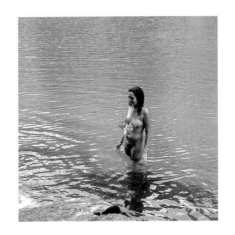

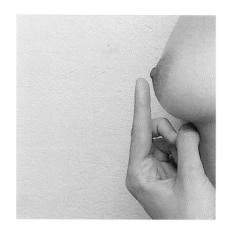

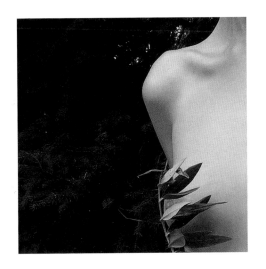

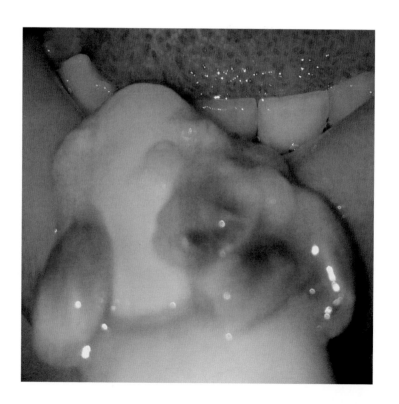

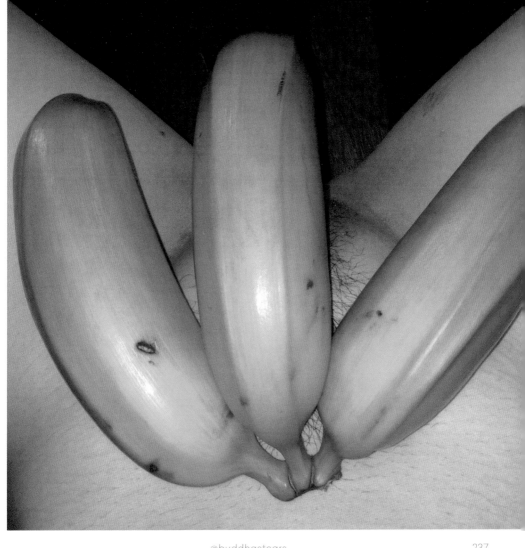

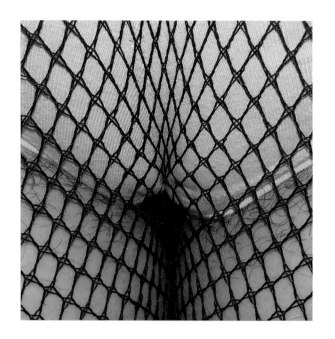

@sloppykittty

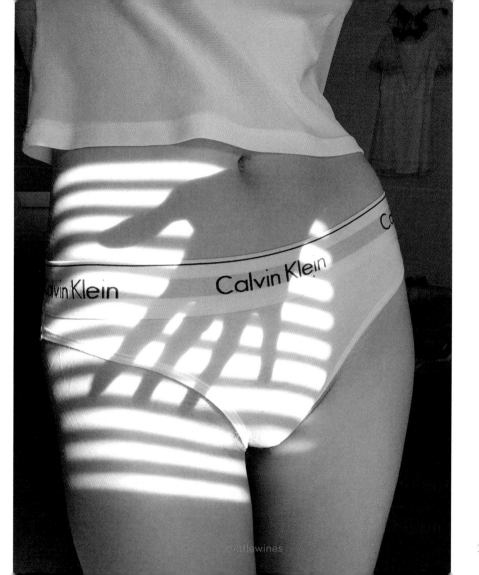

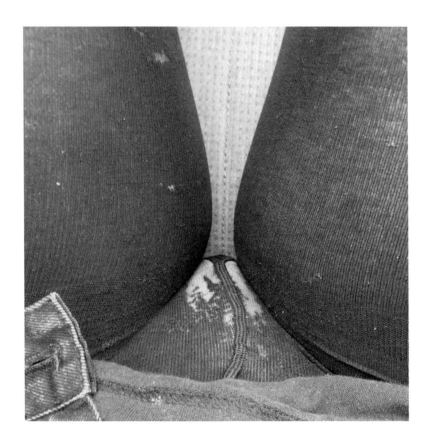

240

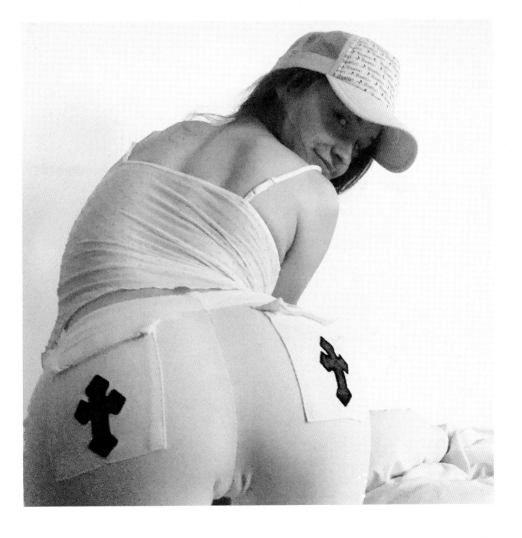

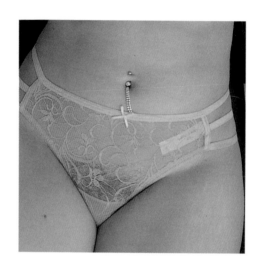

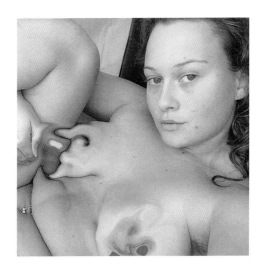

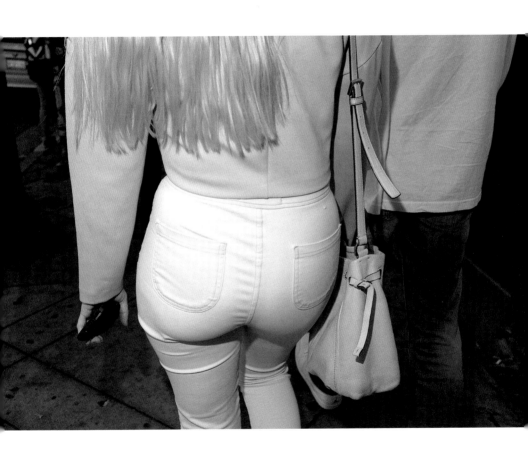

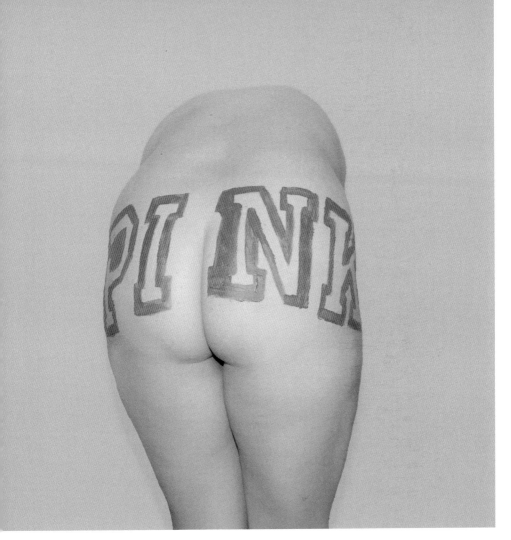

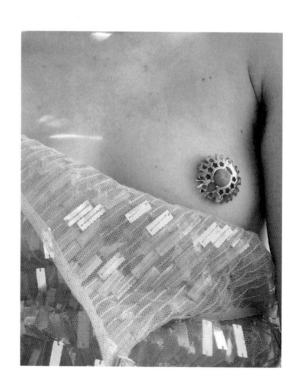

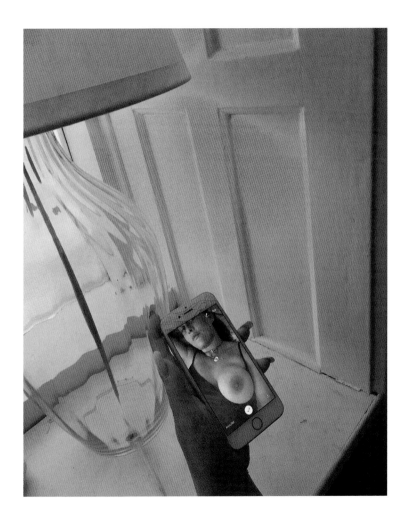

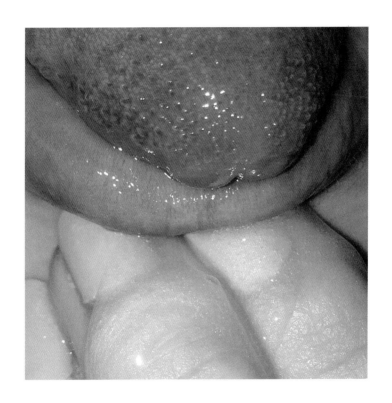

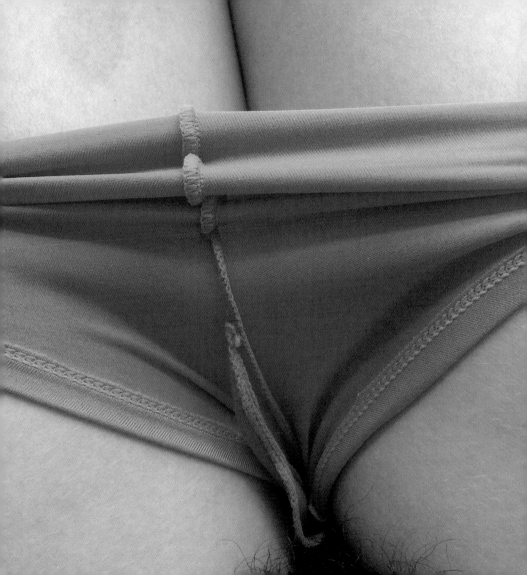

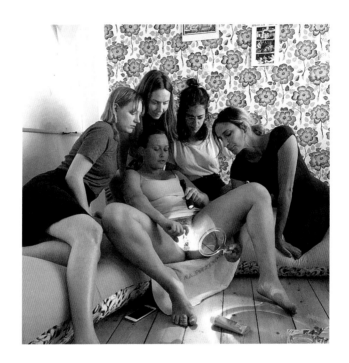

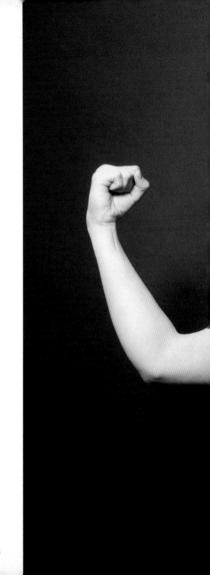

@wuthering_tights

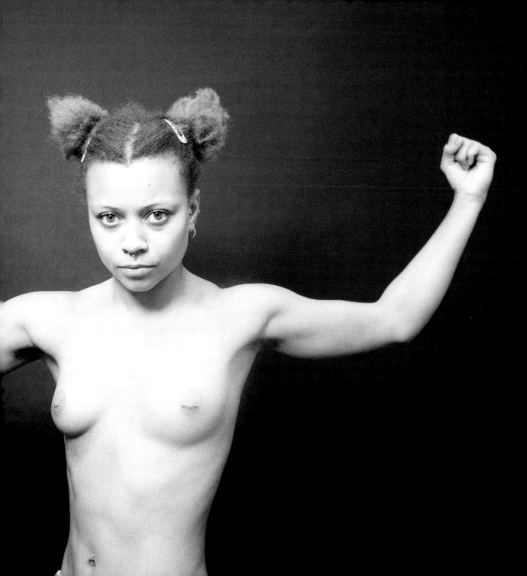

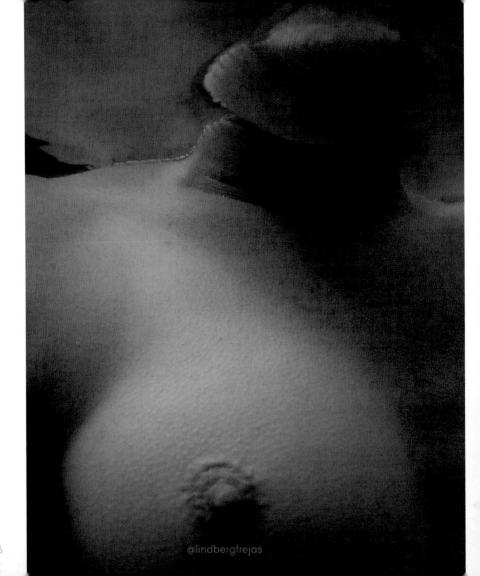

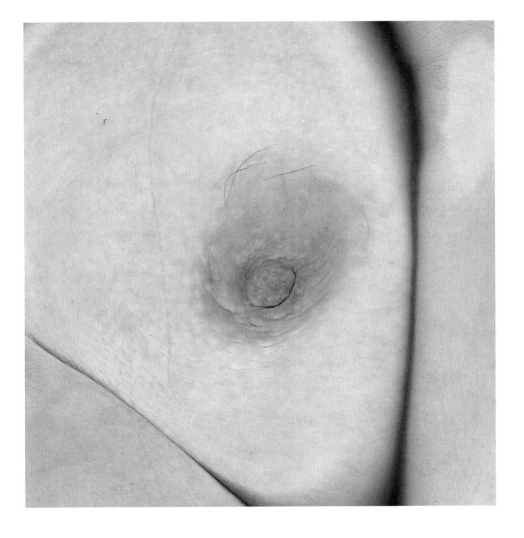

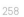

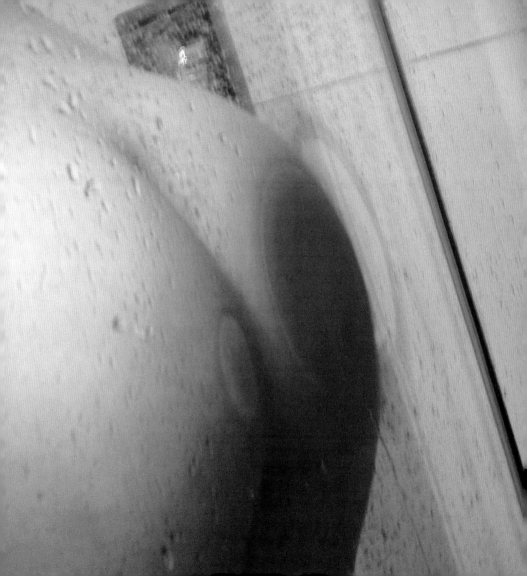

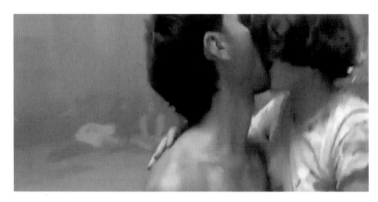

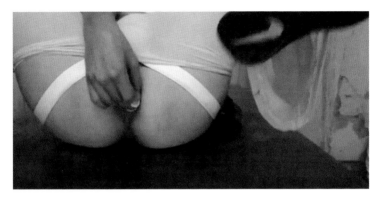

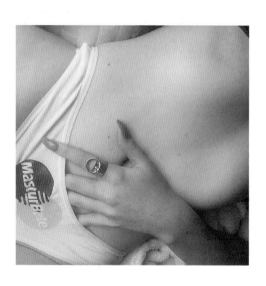

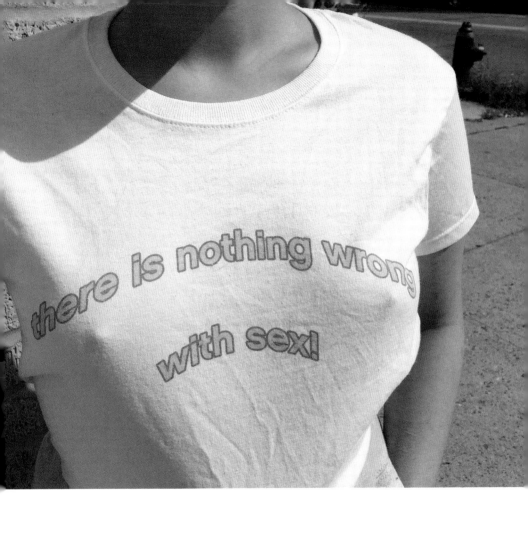

there is nothing wrong with sex!

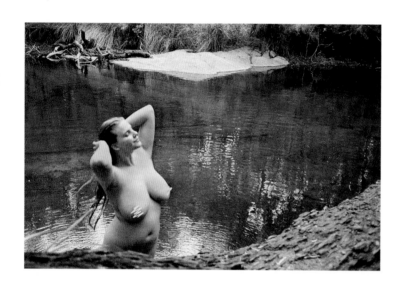

@rosieruthbiddle

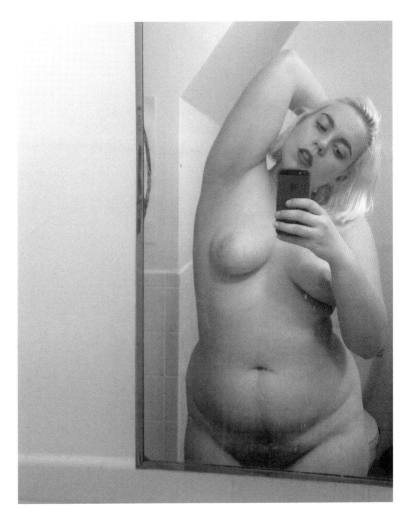

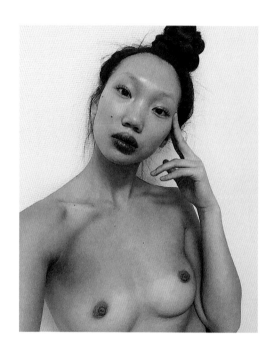

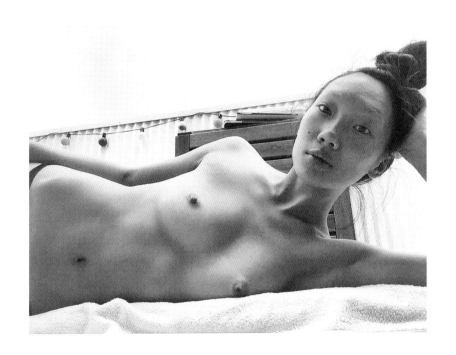

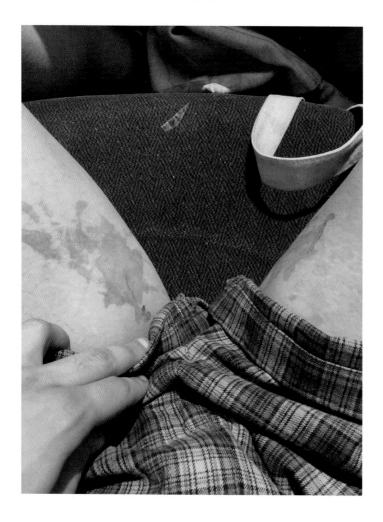

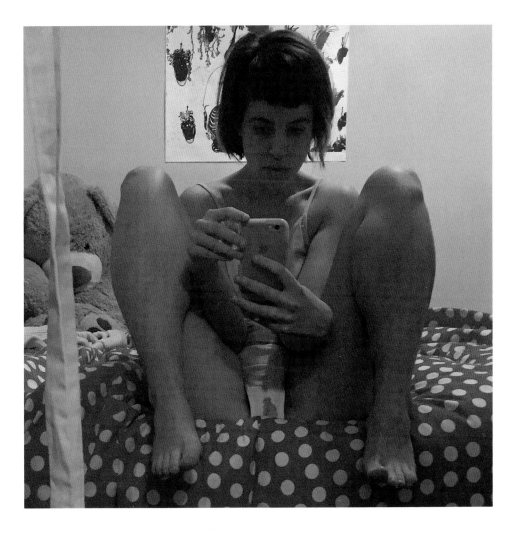

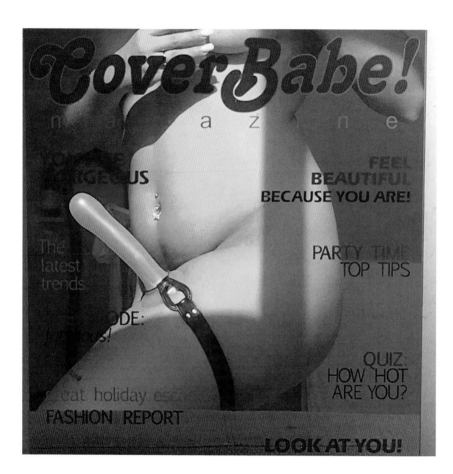

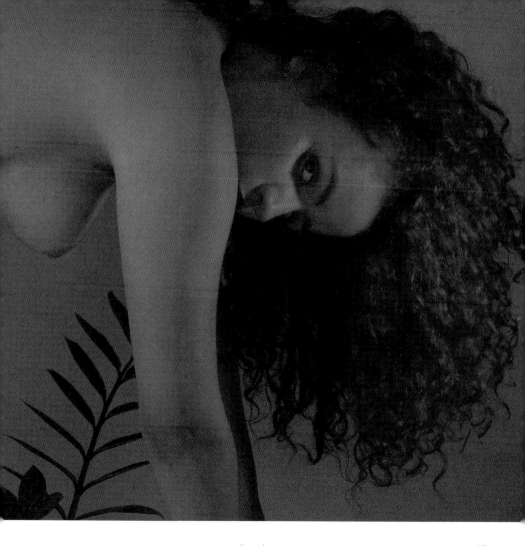

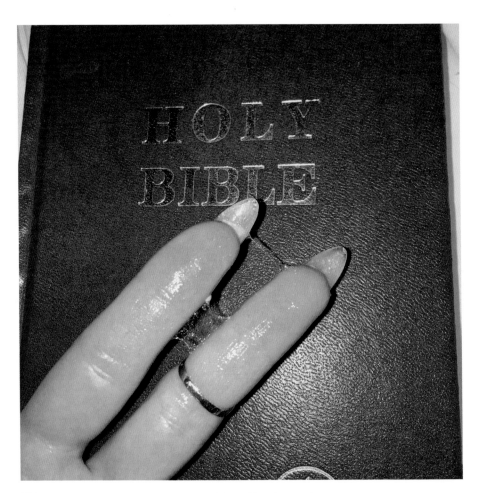

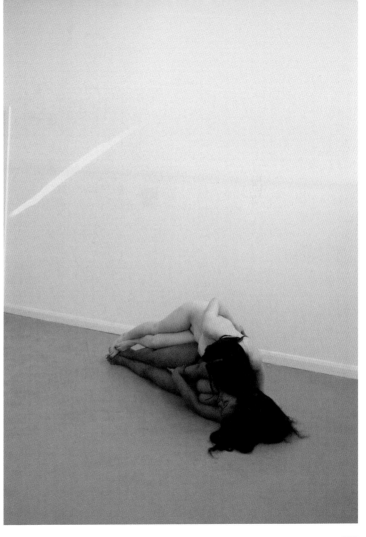

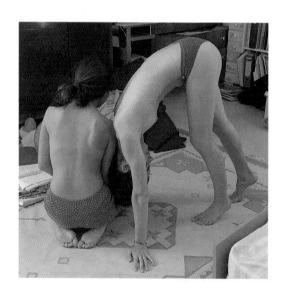

@besosderebeka

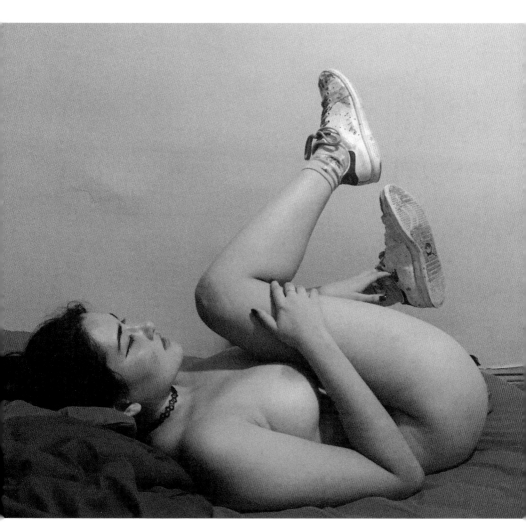

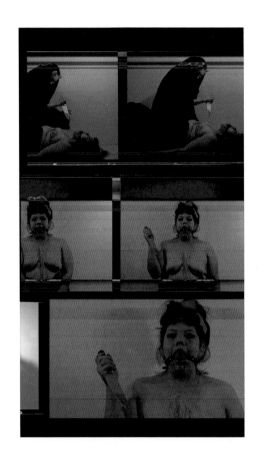

@leather_papi

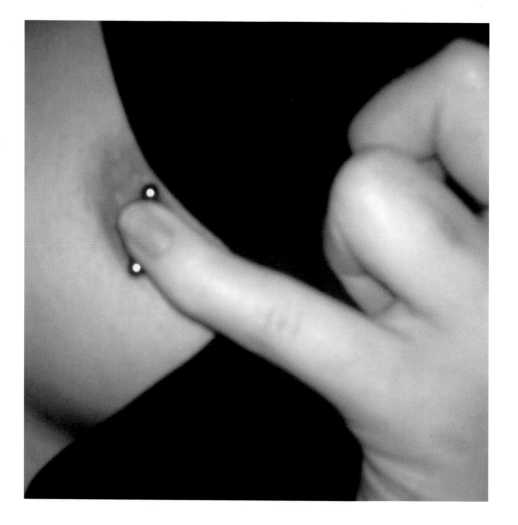

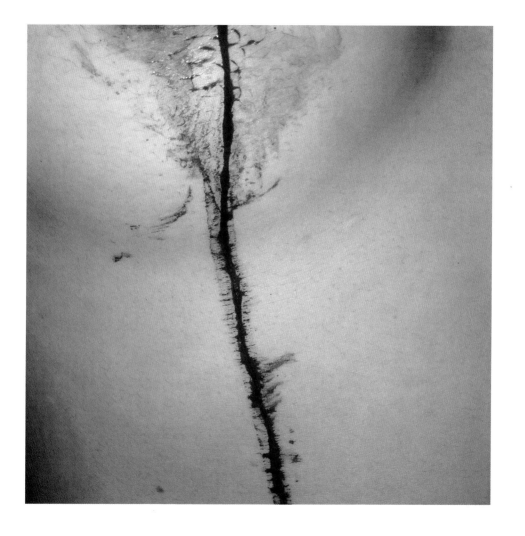

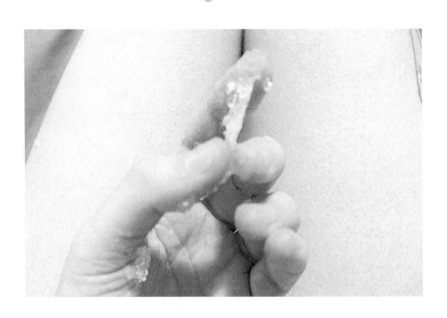

@anonymous

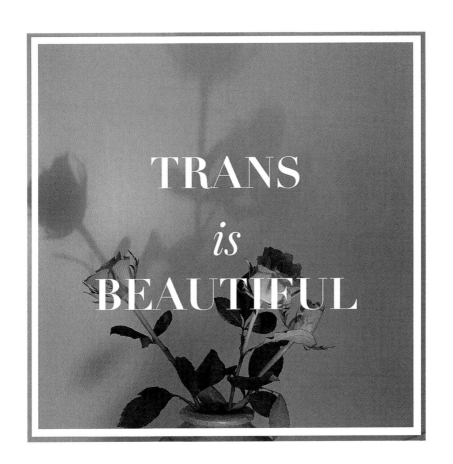

TRANS

is

BEAUTIFUL

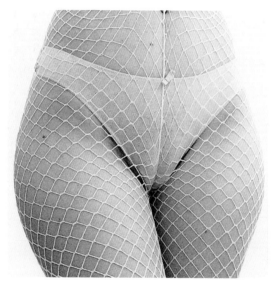

@arvidabystrom

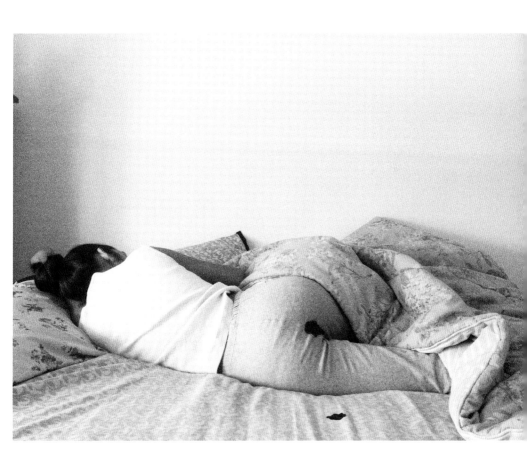

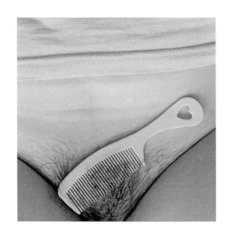

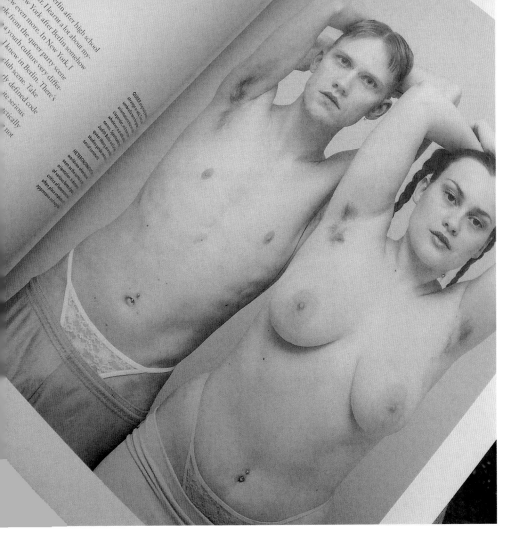

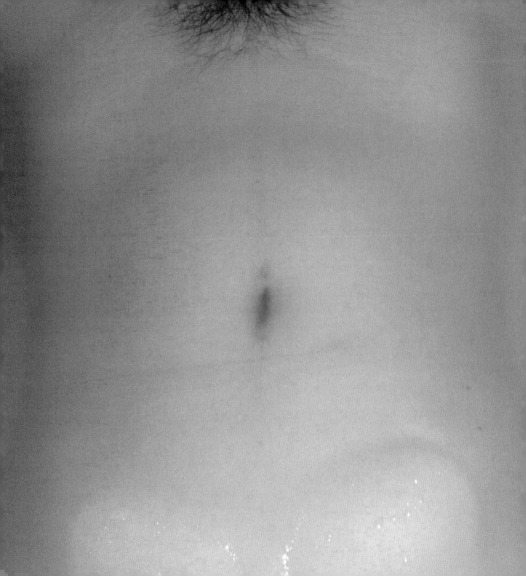

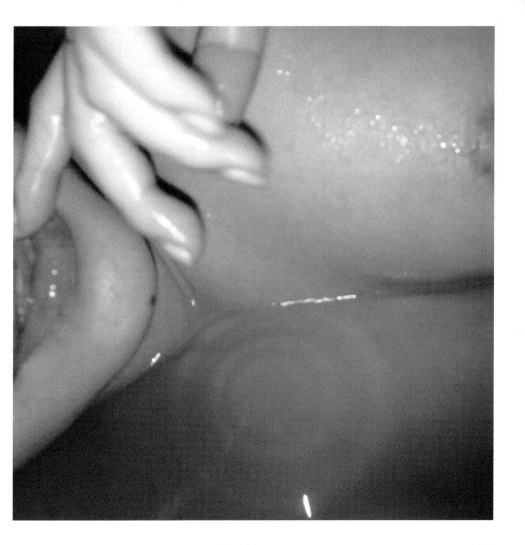

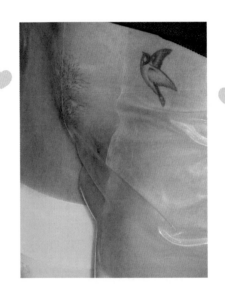

@harleyweir

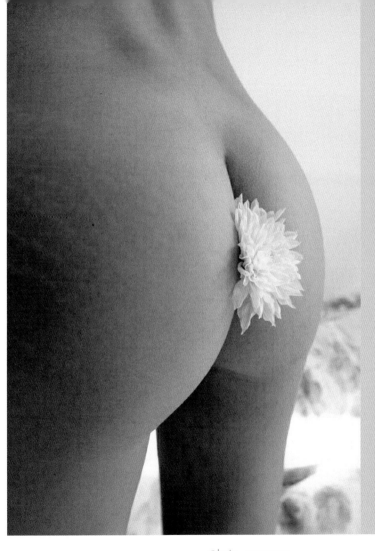

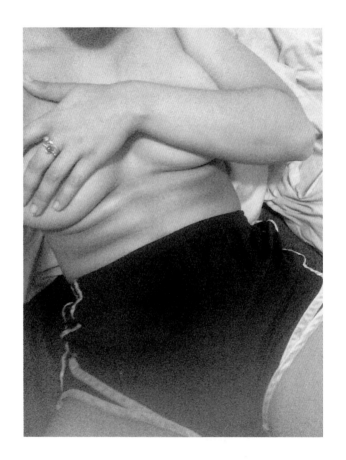

@boyboy.girlgirl

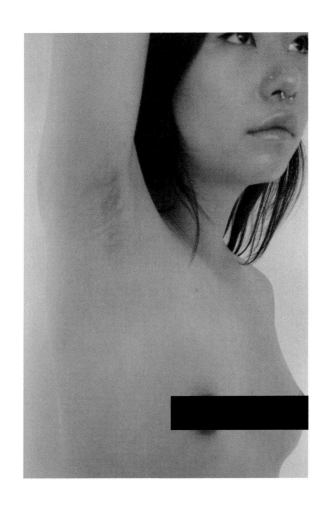

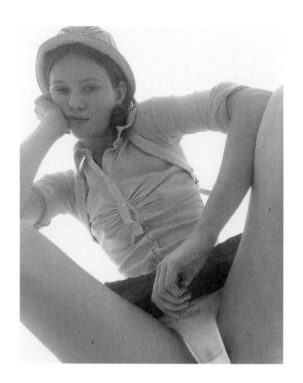

@arvidabystrom

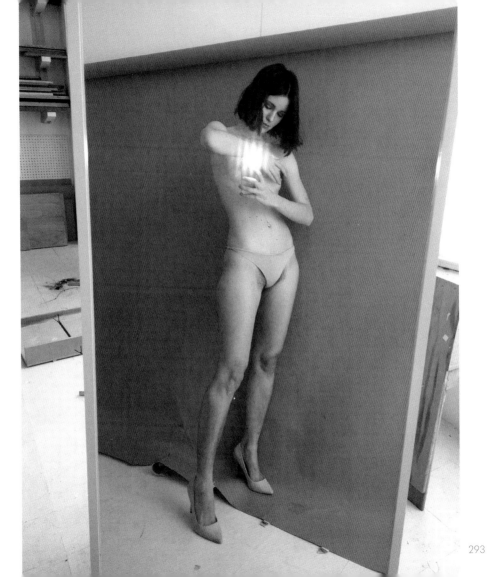

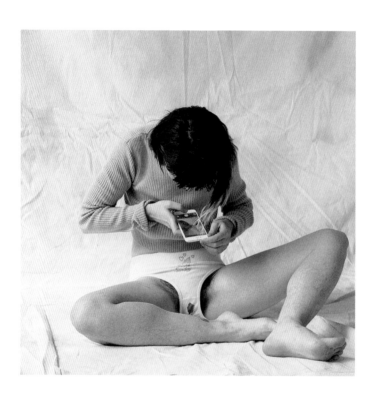
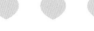

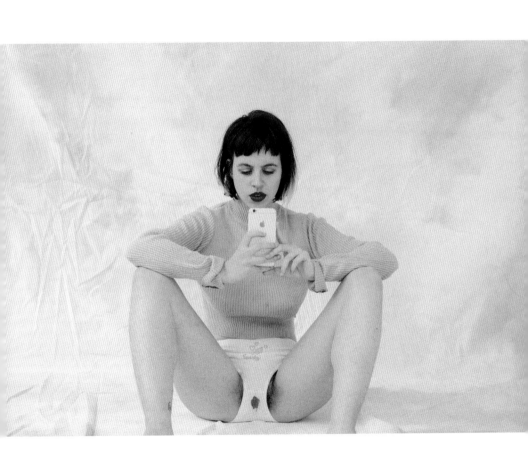

Picture Credits

Cover: © Arvida Byström and Molly Soda

Images courtesy and ©: Maja Ahnborg (p. 156); Jaana-Kristiina Alakoski (pp. 80–81, 114–15, 257); Andrew David Alexander (p. 191); Alien Art (p. 135); Amanda (p. 126); Anonymous (pp. 142, 150, 208, 223, 234–5, 240–41, 263, 275, 280, 281); Jess Audrey (p. 93); @babeobaggins (p. 219); Payton Barronian (p. 181); Celine Barwich (p. 98); Tanya Bedi (p. 214); @beigetype (pp. 36–7); Isa Benn (p. 213); Rachel Benson (p. 246); Marcie Biddle (model: Rosie Biddle, p. 264); bka (p. 138); Isabella Blewett (p. 123); Astrid Börje (p. 56); Casie Brown (pp. 70, 92); @buddhastears (pp. 40–41, 120–21, 210–11, 236–7, 250–51, 258–9, 278–9, 286–7); Arvida Byström (pp. 31, 45, 75, 102–3, 124–5, 183, 198, 218, 248–9, 282, 292–5); Stacey Colledge (p. 212); Petra Collins (p. 189); Kayla Combs (p. 64); Georgia Corcoran (p. 137); Mar del Corral (p. 225); Lauren Crow (pp. 128–9); Rachel Roze Cuccia (p. 71); Gloria D'Alessandro (p. 229); Allison DeBritz (p. 49); Dora Diamant (p. 221); Rebeca Díaz Larrain (pp. 147, 174–5, 274); Gabrielle Drew (pp. 106–7, 146); Patricia Ellah (p. 63); Lonnaya Evans (p. 127); Lauren Farias (model: Verotica September, p. 201); Nina Flageul (p. 33); Peyton Fulford (p. 145); Zhamak Fullad (p. 291); Torraine Futurum (p. 165); Georgia Grace Gibson (p. 48); Marissa Goldman (p. 76); Felipe Gonzaga (model: Karol Macedo/@kakas.k, p. 271); Michelle Groskopf (p. 245); Florian Hetz (pp. 176–7); Katie Hitt (p. 136); Lily Hollywell (p. 222); Jenna Kay Houston (p. 164); Jamila Jacuzzi (p. 224); Melissa Jane (pp. 168–9); Sophie Jennis (p. 130); Rin Johnson (pp. 88–9); Vera Jörgensen (p. 58); Patrice Julion (p. 105); Kade (p. 82); Allie and Lexi Kaplan (p. 57); Isaac Kariuki (p. 77); Prabh Kaur and Rupi Kaur (p. 283); Tara-Sian Kehoe (p. 140); Denelle Kennedy (pp. 100–101); Lisa Kharas (p. 193); Clifford Prince King (pp. 206–7); Colby Kline (p. 59); Petra Korent (p. 141); Isabelle Ida Kuester (p. 44); Reuel Lara (pp. 72–3); Leather Papi (pp. 38–9, 276–7); Freja Lindberg (pp. 34–5, 163, 256); Margherita Loba Amadio (p. 209);

Matheus Lomonte (pp. 60, 111); Alexa Lopez (p. 74); Marie Lopez (p. 131); Amy Louise (pp. 184–5); Lussuria Lust (pp. 148–9); Maja Malou Lyse (pp. 46–7, 94–5, 178–9, 242–3, 252–3, 270, 284–5); Juliana Maar (p. 62); Caroline Mac (pp. 266–7); Alice Macfarlane (model: Jane Macfarlane, p. 134); Sarah Machan (p. 132); Daisy Magnusson (p. 139); Hayley Mandel (pp. 204–5); Camille Mariet (pp. 186–7); Maya Martinez (pp. 232–3); Holly Mason (pp. 154–5); Cassandra McCann (pp. 110, 157); Taylor McCann (p. 216); Carlotta Monty Meyer (p. 122); Claire Milbrath (p. 66); Bea Miller (p. 215); Mary Milk (p. 119); Nico-Lou Monheim Carrasquillo (pp. 226–7); Ellen Moss (pp. 254–5); Aleia Murawski (p. 61); Ebba Nilsson (pp. 170–71); Isabelle Nilsson (p. 151); Albert Omoss (pp. 50–51, 96–7, 160–61); Celeste Ortiz (p. 188); Lova Öster (p. 91); Rebecca Owen (p. 265); Mia Page (p. 244); Margaret Palmer (p. 196); Minna Palmqvist (p. 90); Polly Penrose (p. 192); Lee Phillips (pp. 194–5); Julianne Popa (p. 180); Anthony Proa (p. 217); Quinn (pp. 54–5, 272); Ace Radley (p. 78); Rebecka Rafferty (pp. 84–5); Daniel Rampulla (model: Massima Lei, p. 104); Jacquie Ray (pp. 68–9); Mikena Richards (p. 200); Sabella (p. 143); Ana Sánchez Bellod (p. 52); Alyssa Sanderson (p. 199); Nadia Marie Eckholdt von Schädtler (pp. 182, 220); Lina Scheynius (p. 167); Chloe Sells (p. 166); Ser Brandon-Castro Serpas (p. 53); Avalon Shields (p. 144); Yul Shift (photo by Andre Baker/@haifa_bro, p. 32); Sarah Sickles (p. 247); @sloppykittty (pp. 86–7, 238); Luke Smith (p. 79); Maya Lanae Smith (pp. 108–9, 290); Molly Soda (pp. 30, 116–17, 190, 197, 268–9); Fiona Sonola (pp. 42–3); Cheyenne Sophia (p. 228); Jane Stanley (p. 262); Nim Kyoung Ran Sundström and Celine Barwich (p. 99); Maggy Swain (pp. 172–3, 230–31, 239); Kate Sweeney (p. 289); Liv Thurley (p. 273); Marie Tomanova (pp. 112–13, 158–9); Amalia Ulman (p. 133); Alex Wallbaum (p. 118); Harley Weir (pp. 202–3, 288); Julie Weitz (p. 83); Alex Westfall (p. 65); Stina Wollter (pp. 152–3); Natalie Yang (p. 162); Fia Yaqub (p. 67); Young Boy Dancing Group (pp. 260–61).

Editor Biographies

Arvida Byström is an artist born and raised in Stockholm, Sweden, and currently living in Los Angeles. She started taking photographs at an early age and, as a teenager, got her first photo commissions through websites including Blogspot, Tumblr and, later, Instagram. Known for her pink-hued aesthetic, she commonly deals with subjects such as femininity and technology.

Instagram: @arvidabystrom

Molly Soda is an artist and Internet personality. Born Amalia Soto in San Juan, Puerto Rico, she grew up in Bloomington, Indiana, and currently lives in New York City. She graduated with a BFA in photography from New York University's Tisch School of the Arts and gained attention through her presence online, especially via platforms like Tumblr. Soda's work is made for and found on the Internet, often blurring the line between private and public space.

Instagram: @bloatedandalone4evr1993

Acknowledgments

MOLLY: Wanna work on the acknowledgments for the book?

ARVIDA: Yesyesyes should we do together or separate ones?

M: Sure! I don't rly have anyone to thank?? Like didn't we say Maja and then idk

A: Hahahahaha

M: The people who submitted?? Everyone involved??

A: Maja, Ali, friends, family, the internet?? Everyone involved!!! The most!!! All the people sending submissions! The people writing the texts.

M: Yes, that's it!

A: How do we write that in a good way hah

M: Let's just take a screenshot of this convo!!

A: Oh yeah!! Thanks and no thanks to the internet and its corporations. THANK YOU to everybody who sent photos even if they didn't make it in the book. All y'all are awesome and are making so much rad stuff.

M: Thanks to everyone who has ever gotten something taken down and still doesn't know what it was, LOL

A: Omg yes. And the reason we are extra thanking Maja Malou Lyse is cuz she came up w/ the title

M: Pics or it didn't happen!!!

A: Ali Gitlow was our amazing editor!!! Really guided us through this!!!

M: And believed in us when we approached her with the idea!!!

A: And thank YOU lil' 💩 angel that we made this book together haha

M: The one who reported ur photo???? LMAO. And thank u to Merray, Chris, Alexis and Sarah for writing texts for the book

A: Omg yes, thank you whoever is out there that reported my camel toe, thank you to the algorithm that made Molly see the tweet

M: HAHA! The texts make the book for me

A: Yeah omg please read them; seriously makes you think. Don't miss out on 'em

M: HAHAHA I love this plug ^^^ Ya can't miss 'em!!!

A: Is that all? I hope we didn't miss anybody

M: I think that wraps it up 🐱

© Prestel Verlag, Munich • London • New York, 2016
A member of Verlagsgruppe Random House GmbH
Neumarkter Strasse 28 • 81673 Munich

Prestel Publishing Ltd.
14–17 Wells Street
London W1T 3PD

Prestel Publishing
900 Broadway, Suite 603
New York, NY 10003

Library of Congress Control Number: 2016954046

A CIP catalogue record for this book is available from the British Library.

Editorial direction: Ali Gitlow
Copyediting and proofreading: Aimee Selby
Design and layout: Nick Shea
Production management: Friederike Schirge
Separations: Ludwig Media
Printing and binding: DZS, d.o.o., Ljubljana
Paper: Profimatt

Verlagsgruppe Random House FSC® N001967

Printed in Slovenia

ISBN 978-3-7913-8307-1

www.prestel.com

FSC
www.fsc.org
MIX
Paper from responsible sources
FSC® C112556